FAMILY PHOTOGRAPHS

& How to Date Them

FAMILY
PHOTOGRAPHS

& How to Date Them

Jayne Shrimpton

COUNTRYSIDE BOOKS
NEWBURY BERKSHIRE

First published 2008
© Jayne Shrimpton, 2008

COUNTRYSIDE BOOKS
3 Catherine Road
Newbury, Berkshire

To view our complete range of books,
please visit us at
www.countrysidebooks.co.uk

ISBN 978 1 84674 099 2

To the memory of my parents, and to Joe and Freya

Designed by Peter Davies, Nautilus Design

Produced through MRM Associates Ltd., Reading
Printed by Cambridge University Press

Contents

Introduction

Photographs are not only treasured family heirlooms but also valuable historical documents, for they can be 'read', scrutinized for details and information, in much the same way as written records.

Frustratingly, many survive undocumented, without any helpful labels or inscriptions. Family historians will want to ascertain a date for these precious pictures and establish who the subjects are. Perhaps their identity is already suspected through oral tradition, in which case accurate dating can help to support – or disprove – long-held theories. A close date-range can also confirm the generation to which an ancestor in a photograph belonged, narrowing down the possibilities where there are several potential candidates.

Several general guides to analysing and dating old photographs have been published, offering advice on how to recognise different photographic formats and processes, research the photographer's studio, identify the physical characteristics of the mount, the type of composition and studio setting, and the clothing worn (see Further Reading: Photographs). All of these approaches are useful and may be combined to derive the maximum information from a photograph.

When looking at photographic portraits, however, what usually strikes us first is the strange, unfamiliar garments in which our ancestors pose before the camera. If we study their dress more closely, we have before us a treasure-trove of evidence, for clothing styles can be identified and accurately dated, providing an indisputable date-range for an image, when other methods may be proving too broad or uncertain to be conclusive. Dress can also reveal personal information about the wearer and may indicate the occasion which inspired the photograph. This book, by concentrating on the fascinating and vital clues offered by dress, aims to guide family historians in dating and interpreting old photographs which span the century from 1850 to 1950.

In the days before every family owned a camera, having a photograph taken was an important event. When clients visited the professional photographer's studio they wanted to create the best possible impression, since their likeness was to be preserved for posterity. Physical appearance and general demeanour acted as powerful outward signs of an individual's place in society, and accordingly our Victorian and Edwardian ancestors dressed up for formal photograph sittings in their smartest, most fashionable garments and accessories, to demonstrate their social status, financial position and good taste.

By the time of even the earliest photographs, people with any fashionable aspirations could keep up with the latest styles, thanks to rapidly expanding communications and improved opportunities for travel. They could visit sizeable towns where shops, tailors and women's dressmakers kept abreast of new clothing trends, while those living in more remote rural areas purchased materials and other fashionable articles from the travelling salesmen who carried their wares from door to door.

Women, especially, were interested in the coloured fashion plates published in magazines and journals (the precursors of today's fashion magazines) which presented seasonal fashion changes, and some magazines carried pattern supplements to aid home dressmaking. Traditionally, most women were competent in needlework, and their task was made easier by the domestic sewing machine, which was coming into general use by the

1860s. Those who could afford to, however, had much of their clothing made to measure by professional tailors and dressmakers, until ready-made garments of reasonable quality and price became widely available, a development dating from the mid-19th century in the case of men's dress, but much later, after the First World War, for women's fashions.

Dating the clothing seen in old studio photographs, then, rests on the fairly safe assumption that usually subjects are wearing their most fashionable garments – or, at least, are dressed in a manner which reflects current styles. Amateur 'snapshots' taken in later decades may also depict subjects 'dressed up' for a special occasion, but even where people have been captured spontaneously, wearing ordinary, everyday clothing, their dress can be identified and dated.

The term 'dress' embraces all elements of a person's appearance – clothing, accessories, jewellery and hairstyles – which combine to present a complete image. We know what the fashionable 'look' was during any period, from the work of specialist dress historians, who have considered various forms of historical evidence – pictorial images, written accounts and surviving examples – to chart the main developments in fashion and create a detailed chronology of dress through the ages (see Further Reading: Dress). With the benefit of a visual time-line, as it were, we can successfully compare, recognise and date the main features of dress worn in any kind of portrait from the past.

Dating dress is not a precise skill, in that it may never be assigned to an exact year. Fashions existed for a period of time (as they do now), and so a reasonable date-range is usually suggested. Women's dress in particular underwent some rapid and startling changes between 1850 and 1950, the fashionable silhouette during the Victorian and Edwardian periods being underpinned by firm corsetry and other artificial aids worn under the clothing, which distorted the shape of the body to produce very distinctive forms. After the 1910s, when constricting and protruding foundation garments fell from favour, the fashionable line continued to be defined by regular changes in the cut of clothing, and shifts in the length and styling of garments.

At any given time, the basic shape of dress was enhanced and complemented by novelties in materials, trimmings, accessories and by changing hairstyles. Identifying a particular feature of dress worn in a photograph, such as the shape of a bodice or the style of a hat, and knowing when it first became fashionable gives an accurate, earliest possible date for that image. The latest date is less certain, but younger women were most likely to be influenced by fashion and quick to adopt new modes of dress, and so the appearance of young or young-ish women in single or group photographs will generally offer the closest date-range for that image – usually to within a few years.

Men's dress was more 'uniform' than that of women between 1850 and 1950, and less subject to fashionable fluctuation. It was marked, rather, by subtle shifts in the use of garments, reflecting different degrees of formality according to the occasion, by trends in tailoring and by changes in the styles of neckwear, hairstyles and facial hair. Consequently, men's dress is more difficult to pin down closely and is therefore usually dateable only to within a decade.

The appearance of elderly men and women in photographs is invariably more conservative than that of younger subjects. Older women in particular often clung to modest, outmoded styles which may well be 20 years out of date (think of Queen Mary!),

a factor which should be taken into account when dating single portraits of elderly subjects.

The dress of children evolved over the years according to its own principles, following developing ideas about the nature of childhood and what was appropriate wear, although during any period it tended to reflect adult dress to some degree. Changing fashions in boys' and girls' dress can be recognised in photographs although images of children and, especially, babies on their own may not always be dated closely.

Special events often inspired photographs in the past, as they do now, especially engagements, weddings, christenings, birthdays and anniversaries. There were also certain other occasions which we no longer observe but which were important Victorian rites of passage, like the 'breeching' of a young boy, when he cast aside his baby robes and donned his first pair of 'grown-up' trousers. Another custom which featured significantly in Victorian and Edwardian society was the public mourning which followed the death of a loved one (or a prominent personage, especially the monarch). Mourning and wedding photographs crop up frequently in family collections, as evidenced by distinctive outfits incorporating specific details or features demanded by etiquette for the occasion, but since these costumes tended to follow the general form of fashionable dress, they can be dated in much the same way.

Sometimes the family historian is faced with photographs of ancestors wearing special forms of clothing and these can appear daunting as they fall outside the realms of fashion. Pictures of members of the armed forces in uniform, not surprisingly, crop up frequently, the two world wars being particularly significant to this survey. The details of military, naval and air force uniforms, with their accompanying insignia, are in fact very precise and an expert in this field can often pinpoint the exact status and role of the subject and suggest a very close date for the image.

Other regulation uniforms, as worn by members of the public services, such as nurses, policemen and postmen, also evolved over the years, and can be identified and dated with reference to relevant websites and archives. Different types of occupational outfits may occasionally appear in photographs, for example, clerical dress and household livery, and these, too, can usually be dated with some accuracy.

Sometimes ancestors pose in timeless-looking 'fancy dress', and here, as in any photograph, hairstyles (and styles in facial hair in the case of men) can aid dating. School groups are popular subjects from the late-19th century onwards and by the 20th century older pupils will generally be wearing school uniform, which again incorporates identifiable features. From the 1920s onwards, a growing interest in physical exercise and the outdoors is evident from photographs of sports teams and groups engaged in activities such as walking, swimming and cycling. These pursuits often required special forms of clothing, or encouraged the development of more casual, comfortable garments, styles which came to have a wider influence on the evolution of dress.

Soldiers, sailors, nurses, workmen, sportsmen and women, widows, brides, babies, schoolchildren, mothers, fathers and grandparents – all the different individuals who make up the colourful history of a family appear in the photographs on the following pages. Their images have been selected and reproduced here not because they were rich or famous (although some of them may have led extraordinary lives) but because their

likenesses are typical of their time and reflect the kinds of portrait photographs which may be found in any family collection.

Our ancestors appear dressed before the camera as they wished to be viewed in their lifetime but their clothing has, in a sense, outlived them, offering up a wealth of visual clues which engage our attention and help to narrow the gap between past and present.

Acknowledgements

I should like to thank Nicholas Battle of Countryside Books and Sue Fearn and Darren Marriott of ABM Publishing Ltd for their invaluable help and support in the preparation of this book.

I am also extremely grateful to all those members of ABM Publishing Ltd staff and ex-staff whose personal collections of family photographs feature extensively on these pages, especially Michael Armstrong, Christine Morris, Sue Fearn, Faith Back and Caroline Davis. In addition, I should like to warmly thank the many readers of *Practical Family History* and *Family Tree Magazine* (both published by ABM Publishing Ltd) who have generously donated photographs for the book – too numerous to name individually but all important contributors. I am also indebted to Nicholas Battle of Countryside Books, to Jean Debney, photograph expert, and to my friend, Katharine Williams, all of whom have permitted me to use photographs from their own collections. Several other friends and clients have also made valuable contributions and for these I am equally grateful.

A very special thanks is due to Jon Mills, professional military expert, who has given generously of his time and skills in providing the dating and analysis of all the army, naval, air force and associated First and Second World War uniforms featured on the following pages.

Note

Researching family history is an ongoing process and, even with the benefit of an accurate date or date-range, some of the photographs featured in this book remain unidentified. If any readers think they may recognise somebody in a photograph, please contact the author, who may be able to put them in touch with the photograph's owner.

In addition, if any readers have further queries about the dress worn in any of the photographs published here, or would like assistance with their own family photographs, please feel free to contact the author: jayne.shrimpton@ntlworld.com

The 1850s

Photographs

Although few family photographs survive from the 1850s, when photography was in its infancy, it is important to be able to recognise portraits from this period. Most will be collodian positives, or *ambrotypes*, which were introduced in 1851. By mid-decade they had largely superseded the earlier *daguerrotype* – a negative image on metal, and the rarer *calotype* – an image on paper. At around a shilling each, even good quality ambrotypes were considerably cheaper than expensive daguerrotypes, and helped to bring photographic portraits within the means of more people.

Ambrotypes are readily identifiable, being images on glass with a backing of black shellac (varnish) or, occasionally, velvet. They were often framed or cased in brass or pinchbeck (an alloy of copper and zinc). Ambrotypes were frequently retouched by hand, using paint to add depth to the image and render the portrait more life-like. There may remain a hint of colour on lips or cheeks, bright gilding on buttons and jewellery, and a suggestion of coloured dress fabric.

In 1858 a new photographic format, the *carte de visite*, arrived in England. The size of a visiting card (around 10 cm x 6.5 cm when mounted), cartes would gain mass appeal during the 1860s but a few late-1850s photographs may represent early examples.

Photographs from the 1850s typically contain no studio props, their subjects looming large against a blank background, although after around mid-decade a small table and a curtain are sometimes present (photographs 3, 5, 6, 12, 14). They generally depict single subjects or small groups of people, their composition usually half length or three-quarter length.

Dress

Women's appearance during the 1850s was generally neat and modest, reflecting the contemporary ideal of womanhood. Tight-fitting bodices and vast, bell-shaped skirts both enhanced the natural contours of the female form and underlined women's dependent status.

Silk was widely worn for formal daywear by the 1850s. Plain fabrics in strong colours were popular, often worn with contrasting trimmings (5, 7, 8, 12) while bold checks and

stripes were also very fashionable (3, 4, 11). After 1856, when the first aniline (synthetic) dye was developed, a range of vibrant new shades became available for dress fabrics, such as magenta, bright blue and bright green, and a hint of these colours may be seen in retouched ambrotypes.

Bodices and skirts were usually made separately, although they often matched, giving the appearance of a dress. The close-fitting bodices varied in style throughout the decade but were generally constructed with the fabric gathered or arranged over the shoulders and narrowing to a small waist. By around mid-decade a front-fastening jacket bodice with basques (that is, with an extension that flared out over the hips) and matching skirt was becoming a popular variation on fashionable 1850s styles (3).

Day dresses were made high, to the throat, set off by a prominent detachable white collar of muslin or cambric, trimmed with lace or *broderie anglaise*, a decorative technique comprising openwork patterns of tiny holes and stitches which was much in vogue during the 1850s (3, 4, 11). The neckline was completed by a round or oval brooch, the most common item of women's jewellery during this decade (1, 3, 7, 8, 12, 13) and/or a silk bow or ribbons (2, 4, 7).

Dress sleeves were generally made narrow at the top, widening to a bell-shaped pagoda sleeve, the most popular shape of the decade. Between c.1857 and 1860 sleeves sometimes fell very wide from the top in an exaggerated version of this style (8, 12). Flared pagoda sleeves being rather short, separate white under sleeves or *engageantes* usually show beneath, echoing the white collar. An alternative, the closed bishop sleeve, was worn sometimes from c.1855 and can help with dating (6).

Full skirts, gathered onto a narrow waist, grew progressively wider as the decade advanced. During the early 1850s they were often layered in flounces, helping to create an illusion of width (1) but fashion was aided in 1856 by the introduction of the metal cage crinoline, a pliable lightweight contraption which tied around the waist under the skirt, negating the need for multiple layers of restricting petticoats. Sometimes the outline of the frame beneath the skirt is evident in photographs (6).

Women's hair during the 1850s was sleek and demure, the ringlets of the 1840s still sometimes worn early in the decade (1) and, occasionally, later, although they were becoming rather outmoded (6). The more usual style was centrally-parted hair worn wide over the ears (2, 3) or, later in the decade, drawn down over the ears into a low chignon (4, 5, 7, 11, 12, 13).

Men's appearance is fairly standard in photographs dating from the 1850s, compared with later decades. Male dress was becoming increasingly masculine, business-like and practical at this time, stressing men's role in an industrial society as workers and providers.

Essentially a man's daytime outfit comprised a three-piece suit worn with a white shirt. Broad black cravats were a common form of neckwear throughout the decade (9, 14), although narrower bow ties were also fashionable (2) and younger men often favoured coloured ties (2, 9, 10).

Suits were cut very narrowly for much of the decade, continuing the slender 'gothic' line of the 1840s (1, 2, 9 10, 14). By the later 1850s, looser styles were evolving, but men's suits

are predominantly slim-fitting in photographs of this decade. The frock coat was the most usual for daywear, this, during the 1850s, being a long-waisted garment with short skirts and wide lapels. Sleeves often look uncomfortably narrow, and extend well over the wrists (1, 9, 10, 14). The 1850s waistcoat, when seen, usually features a deep front opening (1, 2, 9, 10). The three pieces of the suit did not always match, and waistcoats or trousers might be worn in a contrasting fabric (9, 10).

Hair was parted and loosely waved or smoothed down with macassar oil. A characteristic feature of the 1850s was protruding side hair jutting out as a curl above the ears, perhaps from the customary wearing of a top hat (1, 2, 9, 10). Bushy side whiskers were a popular style of facial hair throughout the decade (1, 9), and during the later 1850s full beards began to appear, a fashion originating with the Crimean War of 1854-1856 (2).

Children are not seen very often in photographs of this early date, although babies or sometimes young girls may be depicted with their mother. Girls' clothing was a miniature version of adult styles, although their hemlines are always much shorter, ending at around knee-level (6, 7).

This ambrotype must date from at least 1851, but the lady died in mid-1851, which offers a very close date of early 1851. Her formal day dress is characterised by loosely gathered material fanning out over the shoulders to converge at the waist in a V-shape, the skirt made with deep flounces. Her pagoda style sleeves reveal white under-sleeves, or *engageantes*, which complement her prominent lace collar. Her hairstyle, dressed into ringlets, is carried over from the 1840s. Her husband's side-parted hairstyle, with jutting side curls and generous facial whiskers, is typical of the period.

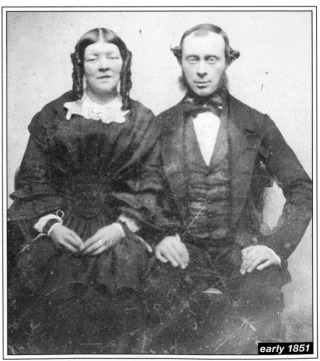

early 1851

1

This couple married in 1856 and, judging from their intimate pose, this photograph originates from after that date, for social etiquette required that unmarried couples did not touch publicly at this time. The fabric of her bodice is arranged into epaulette caps, a recurring feature around this time. Her husband's bow tie with long ribbon ends was an alternative to the broad cravat.

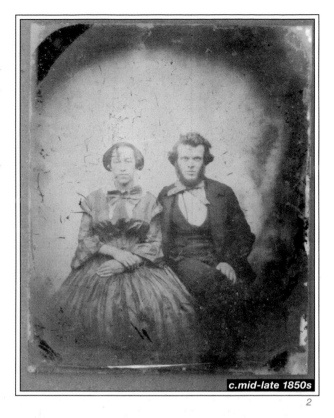

c.mid-late 1850s

2

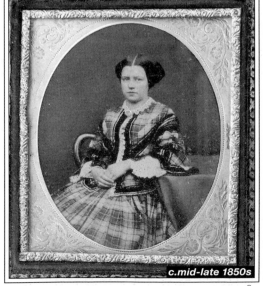

c.mid-late 1850s

3

The faded colour remaining from the retouching of this ambrotype reveals red and green tones for the fashionable, bold checked fabric of this young lady's outfit, which represents the front-fastening jacket bodice style and matching skirt which was becoming popular by around mid-decade. Her centrally-parted hair is raised high at the sides in an exaggerated version of fashionable styles.

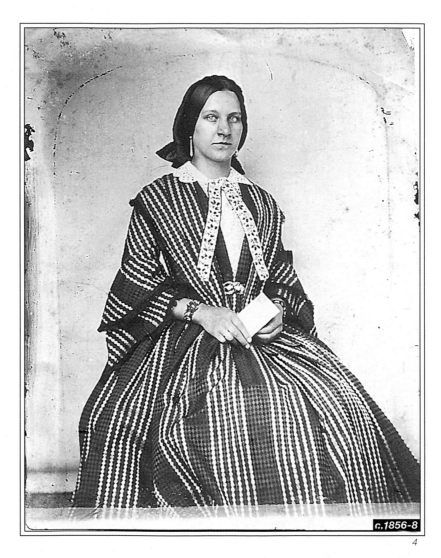

c.1856-8

4

This young lady's formal day dress demonstrates the contemporary love of bold, checked and striped fabrics. The style of her bodice, which incorporates *bretelles*, a broad, cape-like arrangement extending over the shoulders and tapering to a V at the waist, was especially fashionable c.1856-8. Her collar is decorated with the much-admired *broderie anglaise* and she wears an unusual amount of prominent jewellery. Her hair is, typically, parted in the centre and drawn down low over the ears, and is secured behind with a silk ribbon.

The strong blue hue of this formal day dress is clear from the well-preserved hand colouring of the original photograph, and contrasts strikingly with the fashionable black braid trimmings. Her distinctive, close-fitting bodice incorporates *bretelles*, a broad, cape-like arrangement extending over the shoulders and tapering to a 'V' at the waist, a style seen most often c.1856-8.

c.1856-8

5

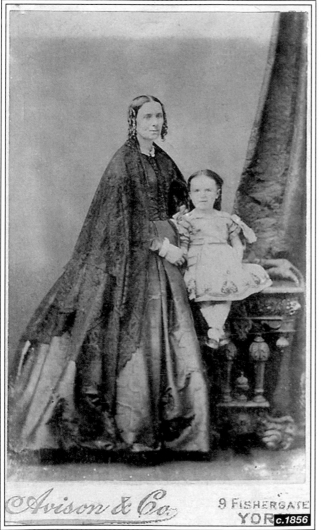

6

The outline of the crinoline frame, introduced in 1856, is clearly visible as a support beneath this lady's wide silk skirt, while her closed sleeves are made in the bishop style, first worn in around 1855. Her long black cloak, similar to the wrapping gown or *peignoir*, is seldom seen in photographs but was a popular type of informal, indoor garment. The little girl was born in 1852.

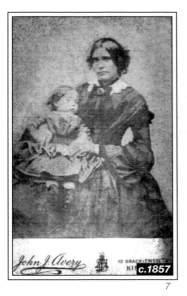

7

The mother's very close-fitting bodice is emphasised by the arrangement of the fabric into broad folds over the shoulders which converge into a V-shape at the front, a style similar in effect to *bretelles* and typical of this period. The child (born in 1855) wears a fashionable full-skirted dress with a draped bodice, which broadly echoes her mother's outfit.

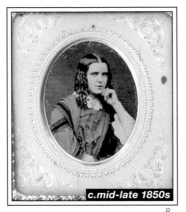

8

Probably aged in her early teens, this young lady wears adult-style clothing but her hair is dressed in long ringlets, a style favoured for girls throughout the 1850s, 1860s and 1870s. The plain dress fabric trimmed with bands of a contrasting colour was a popular theme, while her fine collar and under sleeves appear to be decorated with lace.

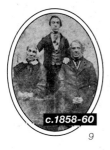

9

The original of this photograph has been identified as a *carte de visite* and must therefore date from at least 1858, while the dress suggests a date no later than c.1860. The son wears the characteristic slim-fitting frock coat of this decade. His father also wears a well-fitting frock coat and the broad, black silk cravat which was a common style during the 1850s. The mother, being an older, married woman, wears a modest day cap.

This broken ambrotype demonstrates the fragility of these early glass photographs. The young man appears to be similar in age to the son in No.9 and his outfit is comparable. His waistcoat is, typically, cut low in front, its double-breasted fastening highlighted by the gilding of the buttons. For neckwear he wears a stylish coloured cravat, knotted, with the long ends tucked into the waistcoat.

10

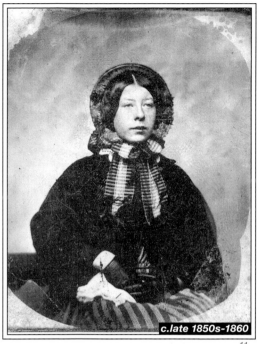

c.late 1850s-1860

11

A rare example of fashionable outdoor dress of this period. Her smooth, centrally-parted hairstyle, draped low over the ears, was fashionable from around the mid-1850s through to the early 1860s, but the round, open style of her bonnet, fastening under the chin with a broad silk ribbon tied in a large bow, narrows the date to the late 1850s or 1860. She wears either a shawl or a short jacket with wide sleeves, popular throughout the 1850s and much of the 1860s, since they sat well with the expansive skirts of these years.

Simple studio props began to be used more frequently from the late 1850s. The young lady's standing position gives a clear view of the fashionable silhouette, especially the fullness of the skirt, which was approaching its maximum width at this time, aided by the vast crinoline frame. Another useful dating clue is her sleeves, which fall wide from the top in an exaggerated version of the pagoda shape, a style seen especially from 1857-1860.

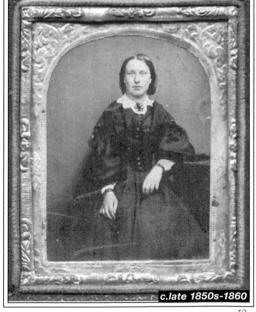

c.late 1850s-1860

12

Cut to fit inside a locket, this oval-shaped photograph reveals little of the subject's appearance, but her sleek, centrally-parted hair, drawn down closely over the ears into a chignon behind, was the prevailing style by the late 1850s and continued into the following decade. The plain fabric of the dress bodice, arranged into vertical pleats, indicates a similar date-range, as does her neat white collar, worn with a modest brooch.

c.late 1850s-early 1860s

13

This elderly gentleman has clearly 'dressed up' for the photograph. His tailored frock coat, cut in sharply at the waist, represents the narrow style which characterised the 1850s and, though looser shapes were becoming fashionable, being an elderly man he would probably be conservatively dressed. He holds a pair of typical Victorian spectacles, which rarely appear in photographs – steel-rimmed, with small, round lenses made of glass or 'pebble' (quartz).

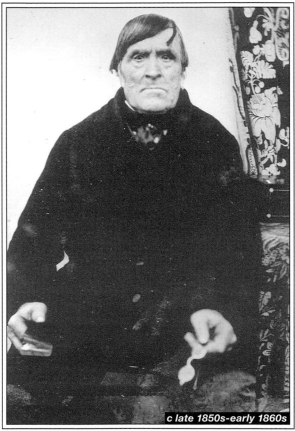

c late 1850s-early 1860s

14

The 1860s

Photographs

The new photographic format from France, the *carte de visite*, (introduced into Britain in 1858), heralded the mass-production of photographic portraits, becoming enormously popular during the early 1860s. Hence, significantly more family photographs survive from this decade. The cartes were given, exchanged and collected on a vast scale. Other formats were subsequently introduced, most notably in 1866 the larger *cabinet* print (typically measuring 16.5 x 11.5 cms when mounted). Like cartes, these sometimes survive in their original photograph albums, which were produced from the early 1860s. Although cartes and, to a lesser extent, cabinet prints are the predominant formats of this decade, good quality, well-framed ambrotypes also continued to be produced.

There is now far more visual evidence useful in dating photographs by way of studio backcloths, furniture and props. Draped curtains are frequently present (3, 10, 11, 16, 18, 20, 21, 22, 23), while subjects often sit at a small table or writing desk (2, 6, 8, 9, 10, 14, 24) and perhaps hold a book (3, 8, 20, 22). Some stand next to or, increasingly after mid-decade, lean on the back of a chair (4, 7, 21, 22). Around this time, classical props such as columns, arches and balustrades also appear, while late in the decade there developed a taste for painted windows or archways framing an 'outdoor' scene (15, 23).

Single portraits are still more common during this decade, but the range of themes expands to include wedding couples and children, who may now appear on their own (15, 16). People are usually represented full-length, or near full-length during the 1860s, offering a more complete impression of their appearance. There is also more variety of pose, subjects sometimes being photographed from a side angle.

Dress

Clothing was becoming more diverse during the 1860s, with new garments evolving for wear on different occasions – work, home, social engagements, sporting events and holidays – reflecting the growing division of the average day into distinct business hours and leisure time. The rapidly increasing pace of life in Victorian Britain, attendant upon improved communications and revolutionary new inventions, also effectively advanced the progress of fashion.

Women's dress in particular demonstrated a proliferation of styles which expressed both a growing desire for novelty and the increasing affluence of the middle classes. The fashionable look altered dramatically between 1860 and 1870, and the different stages in its evolution are usually recognisable in photographs, leading to the possibility of fairly close dating.

Initially, dress was full and opulent, characterised by plain or figured shimmering silk fabrics. The fashionable silhouette, created by a close-fitting bodice and vast crinoline skirt, continued the styles of the late-1850s. Sleeves, generally made in the closed bishop style by the 1860s, were well-padded, while many yards of skirt material, gathered into the waist, created a full, bulky line over the hips (2, 3, 4). During the early and middle years of the decade, a fashionable outfit might incorporate a matching, short *zouave* jacket (2, 3, 4, 18).

By the early 1860s, there was already a pronounced backward sweep to the skirt (3, 4). As the decade advanced the skirt became progressively flatter in front and the emphasis shifted increasingly towards the back (7, 20, 21). Eventually the crinoline collapsed completely, to be replaced by the end of the decade by a high half-crinoline or *tournure*, known popularly in England as the 'bustle', a 'dress improver' worn behind the waist to support the back drapery and long train of the skirt (22, 23).

Following the development of a more slender line, from around mid-decade bodice sleeves narrowed and blouse collars and cuffs became simpler (7, 8, 17, 21), a distinctive feature of mid-late decade being a dropped shoulder line, and the outlining of the sleeve heads (17, 18, 19, 21). Plain dress fabrics were most popular and worked well with new varieties of decorative detailing. Boldly contrasting trimmings and bands of edging were much in vogue from around mid-decade (7, 8, 17, 18, 19, 20). By the end of the 1860s, the new fashionable silhouette incorporating the bustle was reinforced by the appearance of different, more open bodice styles (22, 23) and a revival of the open, flared sleeve (23).

Hairstyles also altered radically throughout the 1860s and offer helpful dating clues. During the first half of the decade, the low, draped chignon of the later 1850s was still popular (1, 2, 6), while an alternative fashion between c.1860 and 1863 was for low ringlets brought forward over the shoulders (3, 4). By mid-decade the chignon was beginning to rise (7, 8) and in the following years significantly more complex coiffures appeared, in which hair was drawn off the face and rose higher in an elaborate arrangement of chignons, plaits and, sometimes, ringlets (14, 17, 18, 19, 20, 21, 22, 23).

As hairstyles increasingly revealed the ears, a widespread fashion developed for the wearing of long pendant earrings in the second half of the decade (7, 8, 14, 17, 18, 19, 20, 21, 22, 23). Generally, more jewellery was worn during the 1860s, other popular items being the neck brooch, carried over from the 1850s (2, 3, 8, 15, 18, 20) and a gold chain suspended over the bodice front (3, 4, 19, 23).

The frock coat remained the most formal male garment and during this decade was tailored generously with long skirts ending at around knee-level, and with broad lapels (9, 10, 12). It contrasted strikingly with the new, easy-fitting 'lounge' suit, which became established during the 1860s as a more casual outfit, suitable for many everyday and semi-formal occasions (11, 13, 14). The 1860s lounge jacket was made quite long, typically to mid-thigh, and featured small high lapels. Trousers and sometimes waistcoats were worn

in contrasting fabrics, trousers being fashionably loose in fit and often appearing rather long.

Neckwear was also diverse during the 1860s, the earlier high standing collar and black cravat creating a more conservative, formal image (12), while turned down collars and coloured cravats or ties were more popular and up to date (9, 10, 14). Men's hair, usually parted to the side, often retained the earlier fullness above the ears (1, 9, 12, 13, 14). There was also a growing fashion for facial hair, which was worn in various combinations of bushy whiskers (13, 14), full beard and moustache (11), or a moustache, preferred by some younger men (9).

Young girls' garments continued to mirror adult styles and so featured a close-fitting bodice and flared skirt, although children's hemlines were made much shorter (5, 15, 16, 23). From around mid-decade they were often trimmed with bands of a contrasting colour, echoing the fashionable detailing of women's dress (15, 16, 23).

For boys, a new type of outfit had developed by the 1860s – a woollen suit comprising a short, open jacket with sloping fronts (what we would call a bolero), with matching short, gathered trousers ('knickerbockers') and a waistcoat (5). Widely worn throughout the decade, this style of outfit was referred to as a *zouave* ensemble, due to the vaguely 'Turkish' nature of the gathered knickerbockers and the jacket's supposed resemblance to the picturesque uniforms worn by the celebrated Algerian Zouave troops who served in the Crimean War of 1854-56 and the Franco-Austrian war of 1859. The *zouave* jacket was popular for girls, too (5).

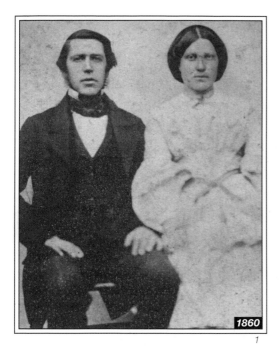

1860

1

Firmly dated to 24 April 1860, the bride's striking outfit offers an early photographic example of the gradual move towards white bridal gowns as the 19th century advanced, although at this date they were generally reserved for more affluent families and not yet a firmly established tradition. Bridal wear followed fashionable lines and accordingly her dress is made in the characteristic close-bodiced style with full crinoline skirt. Her hairstyle is typical of the late 1850s/early 1860s. Her husband's high standing starched collar and broad black cravat are an 1850s' fashion, becoming less popular as the 1860s advanced.

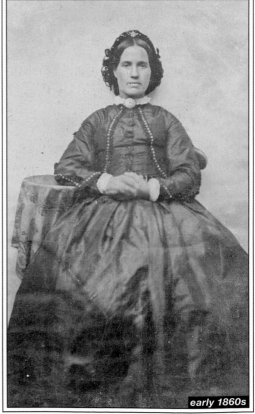

early 1860s

2

The very simple studio setting is typical of the end of the 1850s/early 1860s, as is the subject's stiff, forward-looking pose. Her matching short bolero jacket, worn open, was a popular style early in the decade, its sleeves made in the closed, bishop shape which dominated the 1860s, typically appearing rather padded at this date. Her decorative black day cap reflects the usual custom at this date for married women to cover their heads indoors.

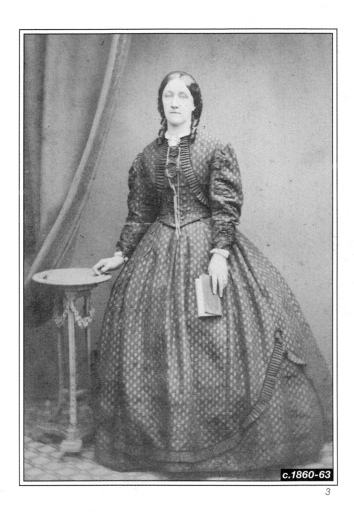

c.1860-63

3

A full-length view reveals strikingly the fashionable silhouette of these years, characterised by a tight-fitting bodice and immense skirt, which, supported by the cage crinoline frame, had reached its maximum size by this date and demonstrates the backward sweep which is characteristic of the 1860s.

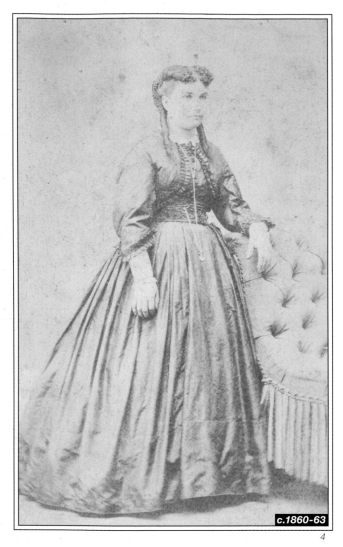

c.1860-63

4

Another fashionable young lady wearing a formal daytime outfit comprising matching bodice, skirt and *zouave* jacket. She follows the contemporary vogue for wearing a long chain looped over the bodice, which may carry a watch or scent bottle tucked into her waist sash, and a key or seal. Her hair, drawn up, curled on top and dressed into two low, tight ringlets brought forward over the shoulders, represents a variation on the fashionable style of the early 1860s.

The occasion for this photograph may be the boy's 'breeching', when he would wear his first pair of grown-up trousers, represented by knickerbockers. Both his three-piece knickerbockers suit, incorporating the characteristic short, bolero-style jacket, and his sister's jacket illustrate the *zouave* ensembles which were popular for children. The little girl leans against a posing stand to help maintain her position during the long exposure time required for the photograph.

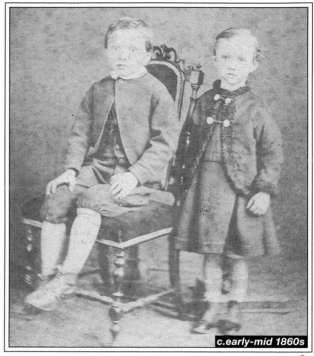

c.early-mid 1860s

5

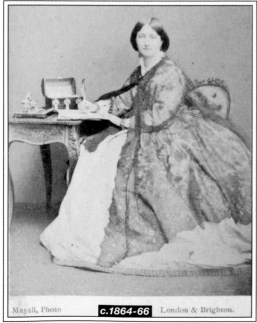

Mayall, Photo c.1864-66 London & Brighton.

6

The celebrated London photographer, J.E. Mayall, first opened his Brighton studio in 1864, giving the earliest possible date for this portrait. Studio props have been arranged to portray the subject writing at her desk and in keeping with this she wears relatively comfortable, informal clothing worn only indoors. The principal garment is her striking, gauzy *peignoir*, a loose wrapping gown, which, as seen here, could be very elaborate. It is worn over a plain dress, whose vast, sweeping crinoline skirt confirms a date before the narrowing of the fashionable line later in the decade. Her centrally-parted hair, drawn down into a low chignon, also suggests a date no later than 1866, for by around mid-decade the chignon was generally drawn back away from the ears and worn higher on the head.

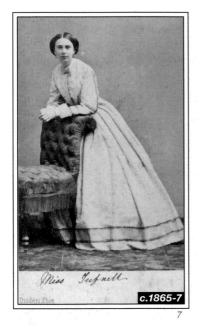

Miss Tufnell

Disderi Phot. c.1865-7

7

This young lady was photographed at the studios of Disderi, the Frenchman who patented the *carte-de-visite* in 1854. She may conceivably have visited his Paris studios, but was probably photographed in London, where he established premises in 1865, a date reinforced by her appearance. Her silk day dress is relatively plain, except for a band of contrasting trimming towards the hem. Her sleeves are quite narrow, compared with earlier years and reflect the slimming down of the fashionable line from around mid-decade.

There is now noticeably less bulk around the hips, an altogether slimmer line, usually seen from around mid-decade. The crisper, more streamlined effect of these years is also mirrored in the sleeves and the neat collar and cuffs. Another dating clue is her hairstyle, which demonstrates the fashion from around mid-decade for a higher chignon, a style which reveals the ears and inspired the wearing of fashionable drop earrings.

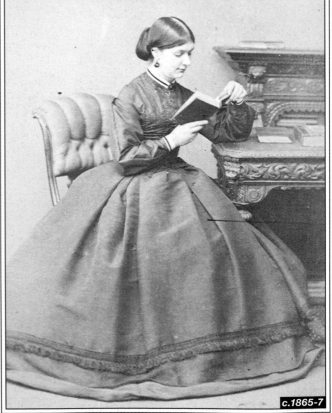

c.1865-7

8

The tailored frock coat, a formal garment cut very differently from the short 1850s version, was now made with long skirts which often extended to the knees. It is cut generously in the loose style which dominated the 1860s. The double-breasted fastening and broad lapels were typical of the period, the velvet collar a popular feature.

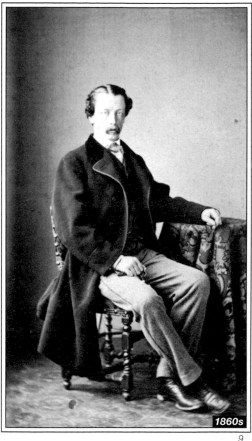

1860s

9

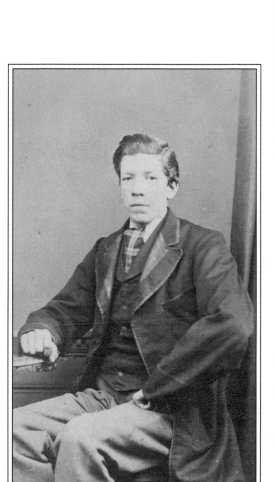

1860s

10

The three-quarter-length composition of this undated photograph is more typical of the 1870s, when the camera moved in closer, but the subject's appearance suggests a date in the 1860s. He is still in his mid to late teens, but old enough to wear a formal adult outfit. His voluminous frock coat has characteristically broad lapels, the partial silk facings and braid binding sometimes occurring during this decade. The trousers are loose-fitting. Like most young men, he wears the more up-to-date style of turned down shirt collar, with a broad cravat, although the bold checked pattern is unusual at this date and lends him a slightly 'rakish' air.

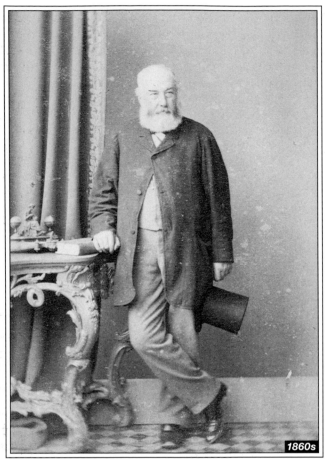

11

The long lounging jacket represents one of the new, comfortable garments which were considered suitable for morning wear. Cut without a waist seam, the jacket appears rather shapeless compared with the tailored frock coat. Typically it features small lapels, is single-breasted and is worn open, fastened only by the top button. The three pieces of the lounge suit rarely matched during the 1860s. The pale-coloured waistcoat is cut fashionably straight across at the waist. A top hat was considered appropriate for wear with this long style of lounging jacket, although it more often accompanied the formal frock and morning coats. Moustaches and full beards were common by the 1860s, especially amongst older men.

This elderly gentleman is dressed in a conservative and very dignified manner in a formal frock coat. Worn open, it reveals the double-breasted waistcoat with a watch chain looped through a buttonhole, the watch concealed in the waistcoat pocket. The stiff, very high standing shirt collar, worn with a broad black silk cravat, was still favoured by older men for business and formal occasions.

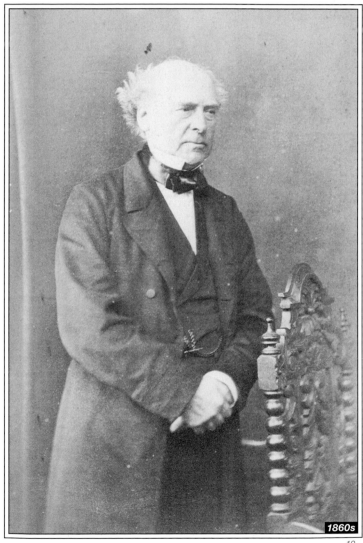

1860s

12

This photograph is believed to commemorate the couple's wedding in May 1866. Being agricultural labourers, they are wearing their best clothing for the occasion, the bride dressed in a good silk day dress (which could be worn again) rather than a bridal gown. Her husband carries a stiff bowler hat, the usual form of headgear for wear with the lounge suit. This style of outfit, less formal than the frock coat and top hat, was generally worn by working-class bridegrooms by this time.

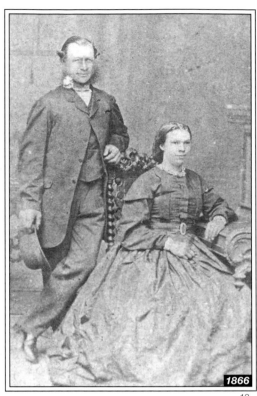

1866

13

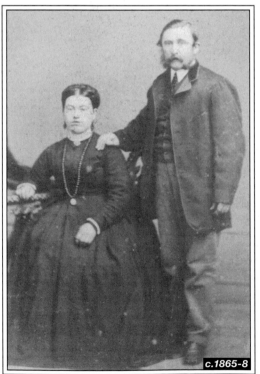

c.1865-8

14

Another newly-married couple in a typical pose, the bridegroom standing behind the seated bride. The bride wears a good day dress made in the close-bodied, full-skirted style which was typical of the early-mid 1860s. A date as late as c. 1868 is, however, possible, judging from her hairstyle, a relatively elaborate coiffure comprising a high chignon, wound around with a plait. Her husband's turned-down shirt collar worn with a long, knotted tie was a popular 1860s combination.

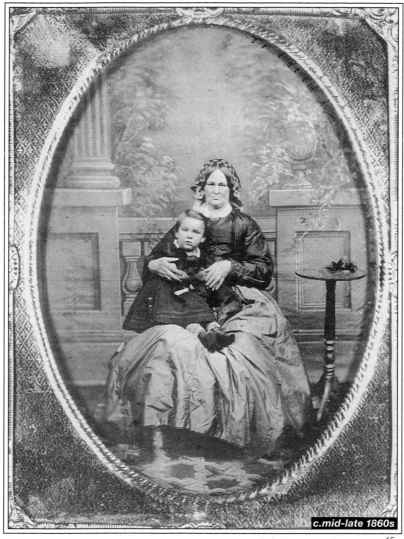

c.mid-late 1860s

15

This striking silk outfit reveals how the separate bodice and skirt of the 1860s did not always match and were, in reality, interchangeable, although usually in photographs they do appear as a one-piece dress. In style, both bodice and skirt demonstrate the bulky fullness which was fashionable earlier in the decade but, being an older woman, she is unlikely to be entirely up-to-date in her dress. Her elaborate day cap is typical of those worn by older, married women.

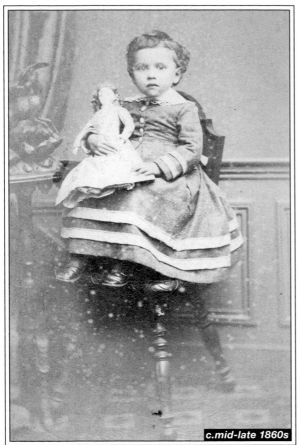

c.mid-late 1860s

16

Aged around three, this little girl would have been incapable of standing upright for the long exposure time required for the photograph, so is conveniently propped up on a seat placed upon another chair. Her tight-fitting, front-buttoning jacket-style bodice and full skirt closely mirror women's 1860s fashions. She still retains the short hair of infancy, not yet grown long enough to style in the ringlets which were favoured for older girls at this time.

A head and shoulders portrait framed within an oval medallion appears to offer no close dating clues. However, the sitter's hairstyle demonstrates the new, more complex styles which were emerging by the mid-1860s. Her dress bodice indicates the neater, narrower lines of the years around and just after mid-decade. The dropped shoulder line, outlined in a contrasting fabric, was typical of these years.

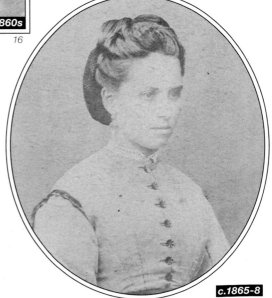

c.1865-8

17

What is visible of this young mother's outfit is also typical of the mid-late 1860s. The baby is engulfed in an elaborate, extremely long white gown, topped with a frilled cap. Mid-19th century christening gowns were, typically, very ornate, as demonstrated by the heavily frilled bodice and sleeves and decorative skirt formed of alternating tiers of lace and tucked or pleated fabric.

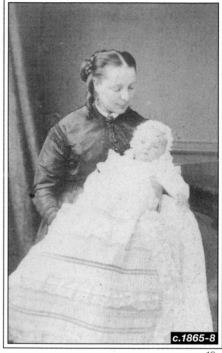

c.1865-8

18

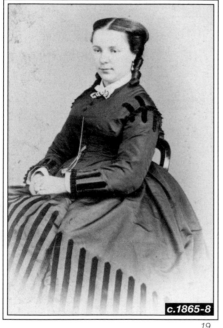

c.1865-8

19

The striking black velvet braid demonstrates the contemporary taste for bold, contrasting trimmings of geometric design. Her hairstyle also exemplifies the experimental styles of this period, the hair drawn well back to reveal fashionable pendant earrings.

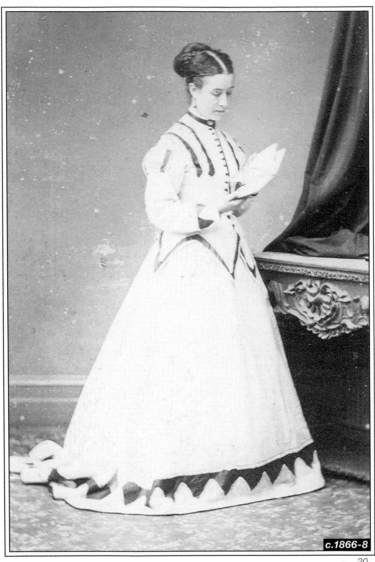

c.1866-8

20

This young lady's stylish outfit demonstrates the typical silhouette of c.1866-8. The distinctive detailing of her dress reflects the Victorian predilection for incorporating 'historical' features into fashion from time to time. The bodice is made vaguely in the style of a late-16th or early-17th century doublet, while the so-called 'vandyking' around the hem was also designed to invoke past styles.

c.1867-9

21

The upholstered, fringed chair demonstrates the developing taste at this time for tassels and fringing. The fashionably plain silk day dress exemplifies the changing line, characterised by a narrower, trained skirt which is almost flat in front, the crinoline being modified by the removal of the upper hoops, leaving only three or four steels to support the hem.

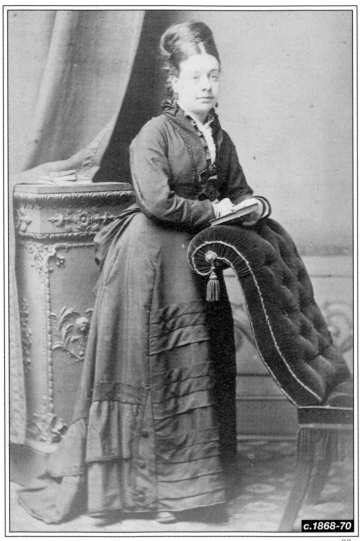

c.1868-70

22

This young lady's formal day dress has almost arrived at the silhouette which came to dominate c.1869-75. Typically, the skirt front is completely flat now, all emphasis being concentrated at the back. Significantly, the skirt fabric is draped up behind the waist, an arrangement requiring the support of the new *tournure*, also called a 'dress improver' or 'bustle' in Britain. Different styles of bodice were also appearing, like this deep front opening, revealing the frilled blouse or chemisette worn underneath.

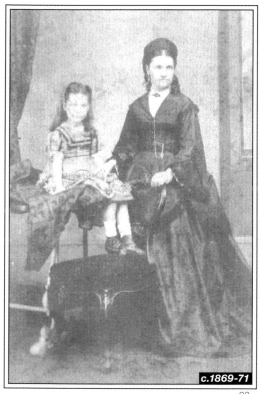

c.1869-71

23

The bodice of this formal, dark silk day dress features a V-shaped front opening, an end-of-decade style, while the flared sleeves represent a new shape, worn especially from around 1870. The bodice, belted at the waist, is extended, creating a double skirt looped up in the bouffant *polonaise* style, while a bustle provides additional support for the drapery behind and the long train. Fashionable fringe trims her dress and her prominent jewellery comprises a brooch, long pendant earrings and a chain with attached watch or scent bottle and perhaps other objects. Her young daughter wears a typical child's dress, made in the tight-bodiced, full-skirted style which echoed adult fashions.

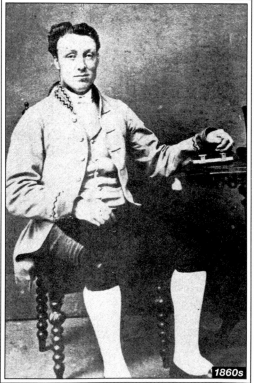

1860s

24

Specialised forms of dress are not readily dateable in themselves, but certain clues here point to the 1860s. The young man (who was baptised in the 1830s and looks to be aged around 30) is dressed in a footman's livery, indicating that he worked as a domestic servant in a large household. Comprising a tailed frock coat, waistcoat, tight-fitting knee-breeches, white stockings and buckled shoes, it was traditionally based on 18th century dress. However, the striking zig-zag braiding on the collar and cuffs dates this to the 1860s, reflecting the contemporary vogue, usually noticed in women's dress, for bold geometrical trimmings.

The 1870s

Photographs

A new form of photograph, the *ferrotype* – more popularly called the *tintype* – appeared in Britain during the 1870s and allowed photographers to capture images away from the formal confines of the studio. Images on a thin, sharp-edged piece of metal, they were developed mainly for the itinerant photographer and were inexpensive products. This is reflected in their quality, but they extended the range of photography still further and people can now for the first time be seen enjoying themselves outdoors (1, 12).

However, most photographs dateable to the 1870s will, typically, be studio portraits: cartes de visite, which were still being produced in large numbers, or larger cabinet prints, both popular formats which were bringing portraiture within the reach of ordinary working people. Ambrotypes had become cheaper by the 1870s but are generally inferior, in terms of both image quality and casing, to the earlier, more expensive examples.

For single portraits, the camera moved in closer during the 1870s so that typically a subject is presented in three-quarter length, his or her feet being cut off, although as in any decade there is also a sprinkling of head and shoulders portraits, often framed within a medallion. Group photographs, whether taken outside or in the studio, as usual show their subjects full length.

Padded velvet chairs are common studio props during the 1870s, for subjects to sit on or to lean against (2, 5, 6, 15, 18), while tables and books are also popular (2, 3, 7, 10, 15). Later in the decade, women are sometimes portrayed holding a letter (14, 17, 18). Painted backdrops depicting an 'outdoor' scene continue (13, 23), and cane chairs also begin to appear during the 1870s (13, 24).

Dress

Technological advances, which affected the clothing and textile industries, and a continuing desire for novelty, resulted in a progression of complex styles for women during the 1870s. However, the significant changes which occurred in the fashionable silhouette around the middle of the 1870s make dating fashionable dress in photographs relatively straightforward as it can usually be assigned to at least one or the other half of the decade.

In 1870 the dominant image was the padded, curvaceous, bouffant silhouette which, having emerged at the end of the 1860s, prevailed until the mid-1870s. The chief features of this style were a close-fitting, short bodice creating a high waistline which accentuated the voluptuous effect of swathes of material draped up at the sides and at the back of the skirt, where it was supported by the *tournure* or bustle (1, 2, 3). Different styles of neckline were worn – high and rounded, long and V-shaped or low and square – whilst a profusion of ornamental frills and bows on bodices and skirts added to the flounced, decorative effect.

Hair was an essential ingredient in this essentially feminine look and the complex arrangements of high-piled chignons and plaits, which were sometimes combined with long, loose tresses during the early 1870s (1, 5), often required the use of false hair. Hats, when seen, are typically small and perched forward on the head so as not to disturb the elaborate coiffures (5, 11).

By around 1874, a new and very different fashionable line was emerging, following the introduction of the longer, tighter *cuirass* bodice, a formidable, heavily boned under-structure, aptly named after a piece of body armour! Shaped so as to extend in an unbroken line over the hips, it effectively smoothed away any bulk around the waist area and forced the bustle projection downwards at the back where it merged into a fall of drapery ending in a train (13, 14, 17). Simultaneously the skirt narrowed considerably, creating a sheath-like effect which was accentuated by the draping and ruching of fabric across the skirt front (13, 14, 16, 17).

This new silhouette was established by c.1875, and was to prevail for the rest of the decade, appearing as either a one-piece Princess dress (14, 15) or separate bodice and skirt. High necklines and very narrow sleeves emphasised the elongated, slender lines while popular trimmings of the later 1870s included black lace at the cuffs (15, 16, 18) and panels or edgings of velvet and other contrasting, textured fabrics (13, 16), a theme which was to be explored more fully during the 1880s.

The narrow look of these years was complemented by much tighter hairstyles, dressed close to the head and secured in a small chignon (6, 13, 15, 18) or, as was fashionable amongst young women, styled into a neat coil down the back (14, 16, 17, 21).

For men, the semi-formal lounge suit was becoming increasingly popular and was narrower in cut by the 1870s, the jacket appearing significantly shorter than the long, loose lounging jackets of the previous decade (1, 7). The morning coat with its characteristic cutaway fronts was superseding the more formal frock coat as the principal garment worn by gentlemen for business or other semi-formal occasions (20). The long frock coat, which featured wide lapels – often edged with silk braid binding during the 1870s – and, usually, a double-breasted fastening, was a sombre, more formal and conservative garment (9, 10, 19).

Neckwear varied but the predominant 1870s combination was a turned down shirt collar teamed with a 'modern'-looking long knotted tie, then called the 'four-in-hand' (1, 7). Sometimes a more formal wing collar is seen (20), or a neat bow tie filling in the gap between the points of the turned-down shirt collar (8, 19).

Men's hair was usually parted on the side, the front hair often flicked or combed back over the top of the head (7, 8, 9, 10, 20). A full beard and moustache were becoming

increasingly fashionable (1, 8, 9), while side whiskers were still common (20). Very young men opted for a clean shaven look (7, 10, 19, 21).

Girls' clothing only caught up with the changing lines of women's dress in around 1880. Typically, then, photographs of the 1870s depict girls wearing outfits which comprise a close-fitting bodice and full skirt, worn short to around or just below knee level. Such garments are easy to confuse with those of the 1860s, especially as the vogue for bands of contrasting trimmings persisted (12, 22). As during the previous decade, woollen stockings are usually pale-coloured (1, 11, 23) or striped (22), and are worn with the customary leather buttoned boots. Hair, once long enough, was still styled in ringlets over the ears (11, 22). Like adults, girls wore fashionable hats when outdoors or when photographed in the studio wearing outdoor dress (1, 11, 12).

For boys too, the woollen knickerbockers suit continued as the principal type of outfit. Leaving behind the *zouave* ensemble of the 1860s, these suits were now generally based on either the sailor suit (see The 1880s) or the 'Norfolk' suit, which derived from men's country and sporting wear and featured a closed jacket tailored with stitched down pleats and cloth belt (12). By the 1870s, open-ended shorts had become an alternative style to the gathered knickerbockers and were worn to below the knee. Boys too usually wore hats outdoors, shapes including wide-brimmed styles and military-inspired caps (1, 12).

Babies and toddlers of both sexes were dressed the same, and were attired very elaborately for photographs and other formal occasions (24).

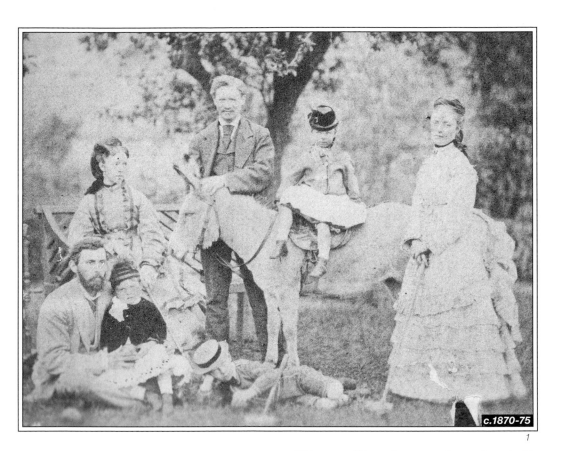

c.1870-75

1

Croquet, like archery, was deemed a suitable outdoor pursuit for ladies at this time. The women's dresses incorporating bustles both exemplify the curvaceous, bouffant silhouette of these years. The men are dressed in relaxed, three-piece lounge suits, and wear their shirt collars turned down with the long, knotted tie, a favourite 1870s combination.

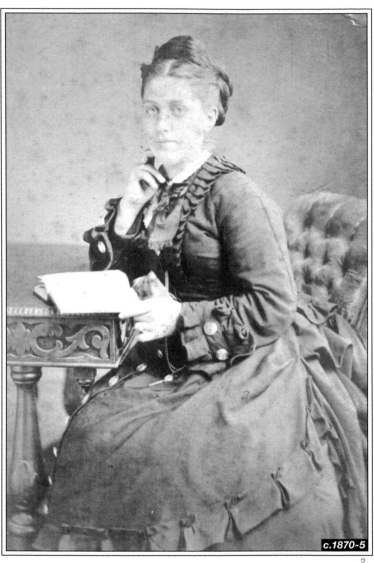

c.1870-5

2

The young lady's formal daytime outfit demonstrates the elaborate, feminine image of these years. Her close-fitting, front-fastening dress bodice features fashionable pleated trimmings, the neckline worn high here, with a small blouse collar and decorative silk bows. Typically, the skirt is constructed in layers, the outer layer looped up in the popular *polonaise* style, with additional drapery at the back supported by the customary bustle.

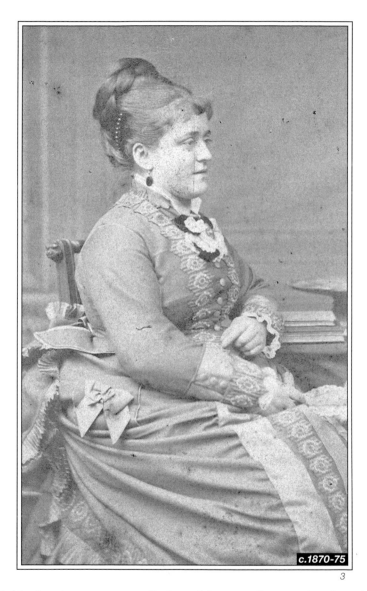

c.1870-75

3

This helpful side view demonstrates perfectly the full, curvaceous silhouette of these years, formed by the close-fitting, high-waisted bodice and draped-up skirt supported by a prominent bustle. The contemporary taste for elaborate, diverse trimmings is also evident from the applied decorative bands on the cuffs, bodice and overskirt. The elaborate plaited chignon, worn high on the head, is also typical of this period.

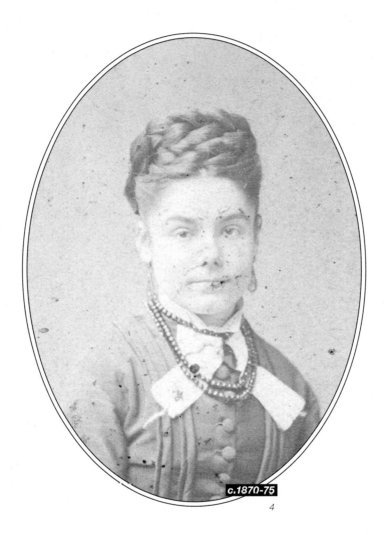

c.1870-75

4

The oval medallion photographic format does not help with dating, but the young lady's distinctive hairstyle is typical of this period, comprising a high piled chignon of elaborately plaited (and probably artificial) hair. Her prominent jewellery adds to the decorative effect, stringed beads echoing the ubiquitous pendant earrings.

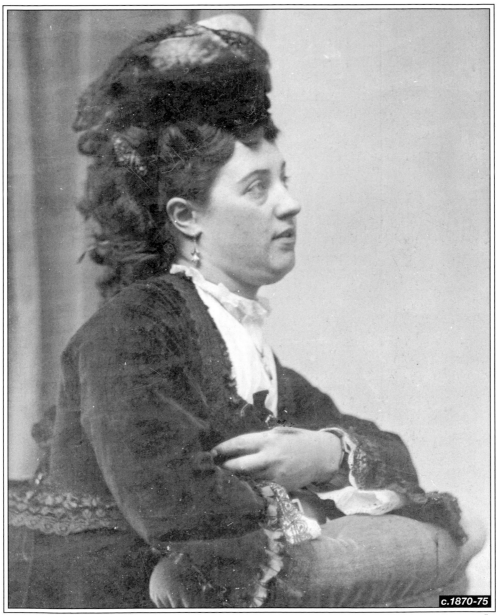

c.1870-75

5

The square neckline of this young lady's bodice was a popular style, filled in with a high-necked blouse or sleeveless chemisette. Her elaborate hairstyle, the sides piled up on top while the back cascades into curls, is a looser variation of the complex hairstyles of these years. Her feather-trimmed hat is also typical, worn toward the front of the head so as not to disturb the hair.

This is mourning attire, clearly evident from the crape bands on her bodice edges and sleeves, and from her black cap, whose streamers or falls are just visible behind her head. Traditionally widows were supposed to wear a separate bodice and skirt, the fitted *basque* bodice worn here being loosely dateable to the 1870s, while a closer date is suggested by the fullness at the back of the skirt. The etiquette surrounding Victorian mourning attire was complex and placed a heavy burden on widows, especially. This lady is probably in the second stage of mourning (following first or deepest mourning, which officially lasted for a year and a day), when the use of crape was restricted to trimmings and white cuffs and blouse collar were permitted.

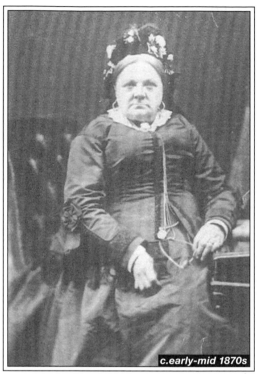

c.early-mid 1870s

6

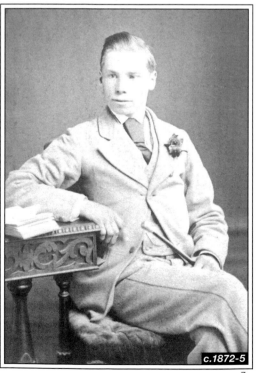

c.1872-5

7

The three-piece lounge suit, a relatively relaxed outfit, was becoming increasingly acceptable for various occasions. Often, all three pieces of the suit matched during the 1870s, as here, and the suit is more tailored now, reflecting the crisper, narrower lines coming into fashion. The jacket is, characteristically, much shorter than previously and here features broad lapels, although jacket collars varied during the 1870s.

Despite the restricted view, it is evident that this man wears a three-piece lounge suit, the jacket and waistcoat clearly matching, as was customary at this time. Another dating clue is the turned-down shirt collar, the most common style of the 1870s, worn here with a version of the bow tie. His oiled hair is fashionably very short at the sides and combed back on top, and he sports a combination of a moustache and full beard.

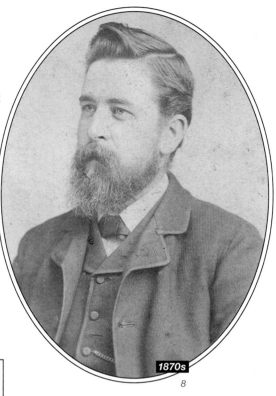

1870s

8

This gentleman appears to be wearing a frock coat, distinguishable from the lounge suit by the bulk of the garment and its double-breasted fastening. The long lapels are also indicative of a frock coat, the silk braid binding on the edges being a common 1870s feature.

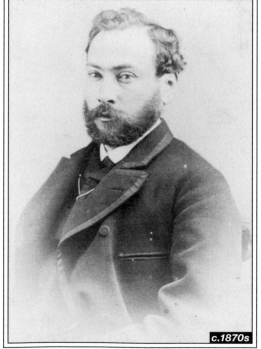

c.1870s

9

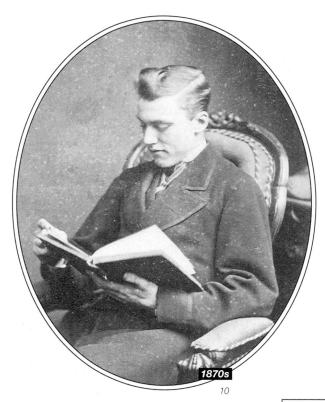

1870s

10

A formal frock coat is readily identifiable here by its bulk and long skirts. A highly respectable and business-like, if rather conservative, garment, it was worn for formal day wear during the 1870s, and was usually tailored in sober black, dark blue or dark grey cloth.

Of these two sisters, the older girl is aged 13 here – no longer a child but not yet quite a woman, she wears a modified version of adult fashions. Her white dress is draped up, apron-style at the front, although it does not appear to feature the customary bustle of this date. The fringing around the yoke and flounced hem are both fashionable decorative features. She wears a modish 'postillion' hat decorated with ribbons. Her sister, born in 1866 and therefore aged six or seven here, wears a short full skirt and her hair is dressed into ringlets over the ears, a style still favoured for young girls during the 1870s.

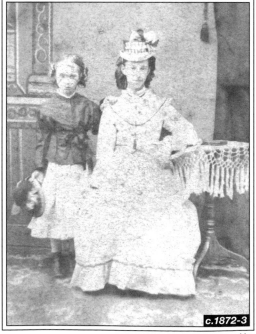

c.1872-3

11

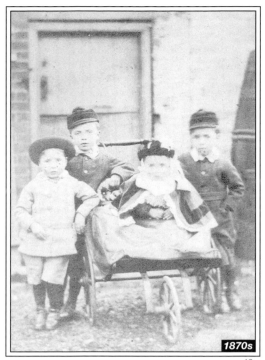

1870s

12

Images of children unaccompanied by adults do not lend themselves to close dating, since juvenile styles of dress typically spanned more than one decade. The toddler in the cart is probably a girl, and her cape offers a useful dating clue, for the broad contrasting bands of trimming were fashionable during the 1870s. Military-inspired headwear was favoured for Victorian boys and these caps were based on the 'kepi' worn during the American Civil War (1861-65), being widely worn during the 1860s and 1870s.

From mid-decade the new *cuirass* bodice produced a distinctively smooth unbroken line over waist and hips. The skirt front is, typically, narrower now, the horizontal gathering giving the impression of the skirt being 'wrapped' around the legs. The lower section of pleats was a late-1870s/early-1880s feature while the contrasting fabrics were a popular decorative theme. Being a mature married woman, she wears modest white frills at the cuffs and neck and a day cap, made in the close-fitting neat style of the period.

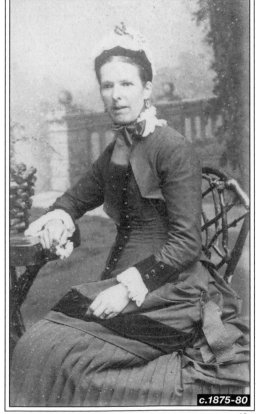

c.1875-80

13

The characteristic cascade of back drapery is clear here, the fabric extending into a train until c.1880. This sheath-like silhouette was ideally suited to this style of one-piece dress, whose narrow shape is emphasised by horizontal gathering or ruching across the front of the legs. Named a 'Princess' dress, after Princess Alexandra, wife of Edward, Prince of Wales, it was extremely popular by 1876.

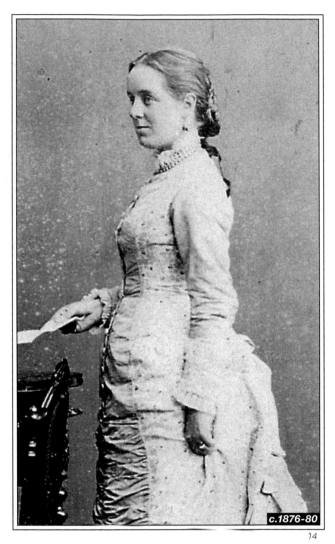

c.1876-80

14

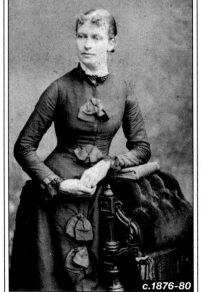

c.1876-80

15

A row of decorative bows down the front was a popular feature of the Princess style and emphasised the fashionable vertical line, while the cuffs demonstrate the contemporary vogue for black lace. The small chignon at the nape of the neck, worn with a short curled fringe, was another association with the stylish Princess of Wales.

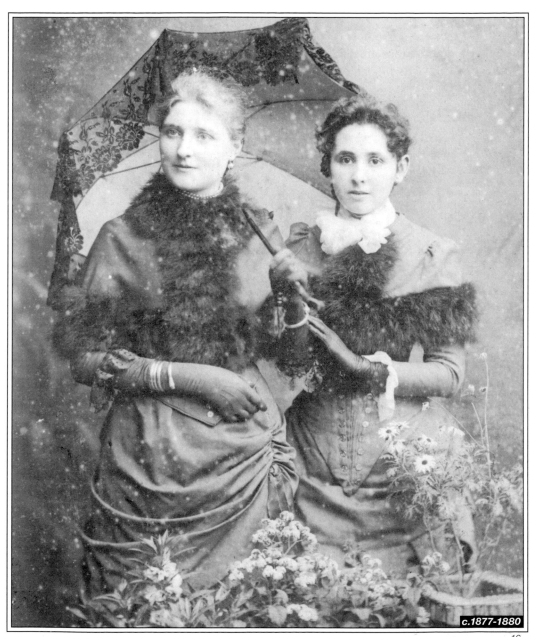

c.1877-1880

16

Very fashionably dressed, the two women wear similar fitted shoulder capes heavily trimmed with either a shaggy long-piled wool or fur, both being popular for winter. The visual effect of a combination of textures was much admired during the later 1870s/1880s, as also evidenced by the black lace edging on the ladies' parasol and the dress sleeves on the left.

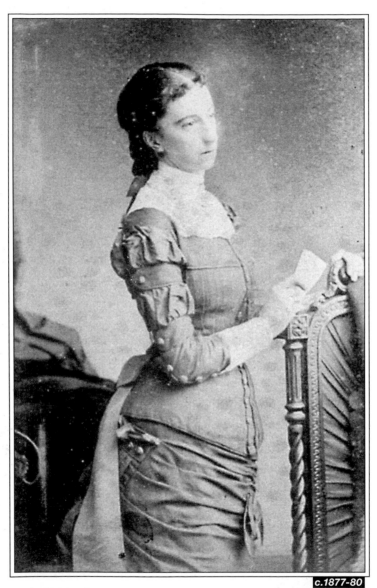

c.1877-80

17

Characteristically narrow sleeves are made with decorative buttons and puffed at intervals in vaguely 'Renaissance' style, demonstrating the enduring Victorian fascination with 'historical' detailing. Her hair is dressed fashionably close to the head, the neat coil of hair extending down her back in a style favoured by young women.

eing elderly, this lady has not adopted the extreme sheath-like fashions favoured by young women. Made in a modest, layered style comprising a jacket and a tunic-like overdress worn over a pleated under-skirt, her outfit is easier in fit than the rigid, figure-hugging garments demanded by high fashion and therefore less closely dateable. Black clothing was considered the 'correct' formal wear for older women during the Victorian period, whether in mourning or not.

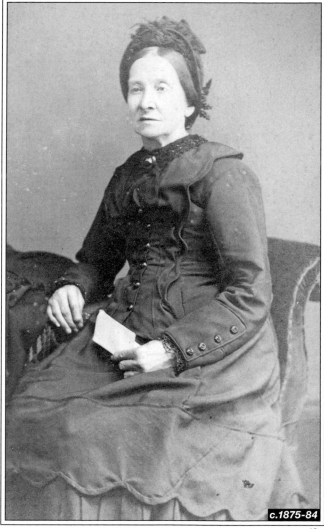

c.1875-84

18

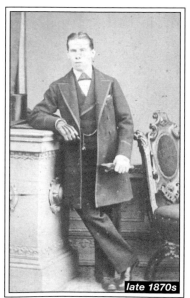

late 1870s

19

In this unusual (for the 1870s) full-length composition, we see the archetypal conservative mid-Victorian gentleman dressed in formal day wear. His frock coat, identifiable by its long straight front edges and double-breasted fastening, demonstrates the slimmer lines which were well established by the later 1870s. Appropriate accessories complete his immaculate appearance – a business-like watch chain suspended across the waistcoat front, a pair of leather gloves, and a top hat.

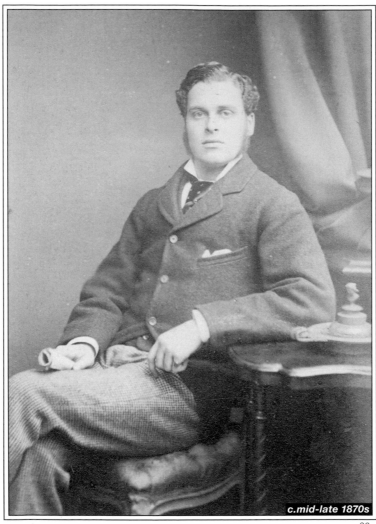

c.mid-late 1870s

20

This well-dressed young man wears a three-piece suit comprising a morning coat – identifiable by the cutaway front which slopes away from the lower button fastening – with a matching waistcoat and contrasting trousers, a popular combination for this style of outfit. The cut is characteristically narrow at this date. Many younger men wore side whiskers without a moustache during this decade.

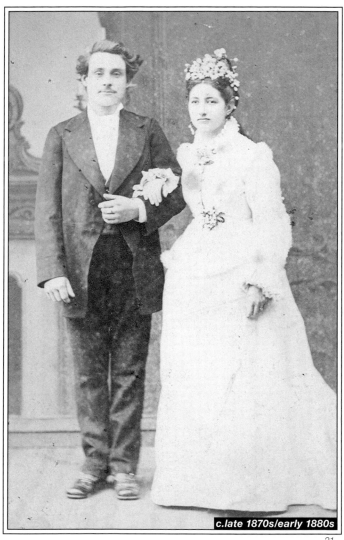

c.late 1870s/early 1880s

21

The bride wears a white or ivory wedding outfit, suggesting that she was reasonably well-off. Bridal dresses followed the fashions of the day and took the form of semi-formal day wear. Veils were sometimes worn by 1870s' brides, but instead this young woman wears a profusion of orange blossom in her hair, echoed by the corsage on her bodice. By comparison, the bridegroom does not look particularly well-dressed in his rather ill-fitting lounge suit, although he sports a white bow tie, which was the neckwear usually reserved for evening wear or very formal occasions.

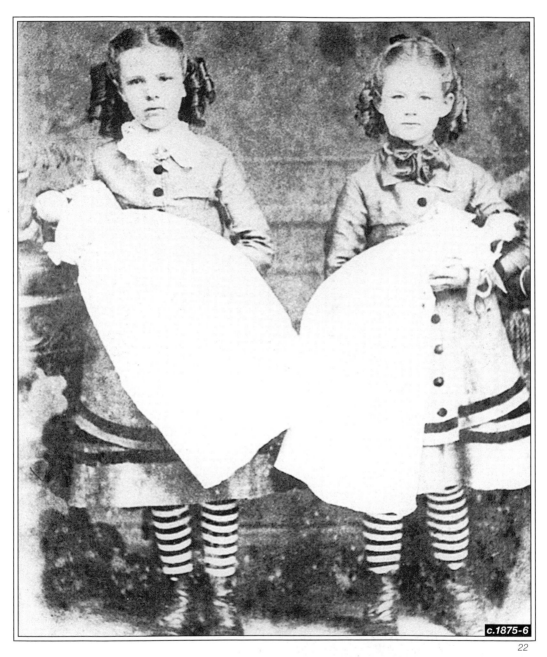

c.1875-6

22

Dressed almost identically, these sisters wear long, front-buttoning jackets fitted to the waist before flaring out to thigh level over the top of knee-length, full skirts. The contrasting decorative bands of trimming were common features of children's garments throughout the 1860s and 1870s. Their striped woollen stockings are worn with buttoned leather boots.

This studio photograph depicting a grandmother and her granddaughters is closely dateable from the known birth dates of the baby (1878) and the girl (1875). Their appearance generally supports this date range, although being respectively elderly and very young, none of them displays the up-to-date fashions which are most readily dateable. The most outstanding feature is the striking black and white checked fabric since such a bold design was not especially fashionable at this date. A provincial style, it was the sort of material which might be purchased for home dressmaking.

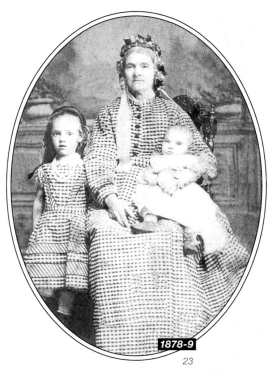

1878-9

23

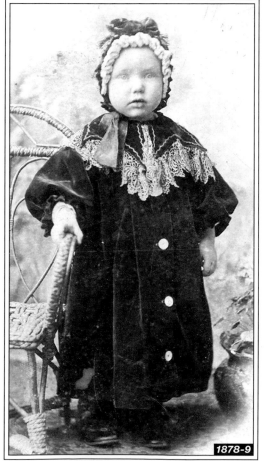

1878-9

24

This toddler wears a white frock – just visible at the neck and right wrist – under an outer gown or coat of velvet or plush (a type of cotton velvet with a long pile). Soft, textured fabrics in rich deep colours such as black, maroon and dark brown were especially popular during the later 1870s/1880s. It does not appear to be very practical, but for comfort and convenience the gown is loose fitting. His fashionable infant's bonnet of velvet or plush is secured with a satin ribbon.

The 1880s

Photographs

Outdoor photography continued to flourish and natural, outdoor scenes will be likely to feature in any family collection from this decade, especially following the introduction of the *gem tintype* at the end of the 1870s. Measuring a mere 1 x ½ inches, it became the smallest commercially-produced portrait. Despite this, however, professional studio photographs will still predominate. Cartes were still being produced in large numbers during the 1880s while the larger cabinet prints became more widespread at this time. Ambrotypes, however, are rare by the 1880s.

As usual, groups of subjects (whether outdoors or indoors) were taken from a distance, and are portrayed in full-length. Single subjects photographed in the studio are generally depicted standing, usually in three-quarter length, as during the 1870s, although the occasional full-length or head and shoulders composition occurs.

Interior settings often show their subjects leaning against a lectern or plinth (photographs 8, 11), or standing next to or leaning over a chair (3, 6, 17). Small tables with potted plants are also popular later in the decade (13, 15, 21). At the same time, painted backdrops depicting 'rustic' scenes demonstrate attempts at a more authentic look during the 1880s, with texture becoming increasingly important, as evidenced for example by the use of bark for fences (10). Some new props were also introduced around this time and may help with dating, for example a swing (1) and furry or shaggy woollen rugs (4, 12).

Dress

Women's dress in the 1880s was, again, complex in construction and underwent very distinct changes that are helpful in dating photographs. In 1880, the fashionable female silhouette was still sheath-like, although the 'look' of the new decade was markedly different. The cascading back drapery and long trains of the later 1870s having largely disappeared for day wear, the typical day dress of the early 1880s featured a narrow skirt with a significantly shorter hemline, generally ending at around ankle-length (seen best in photograph 1).

The general effect of these years was elaborate, skirts being layered, often in tiers of regular kilt pleats or smaller knife-edge pleats, and embellished with bows and vertical

ribbon trimmings Further ornamental effects were produced by the puffing, gathering and ruching of skirts and bodices (1, 2, 3, 4). Bodices were close-fitting, and featured very narrow sleeves, often worn well above the wrist, revealing the white frilled cuffs of the blouse (1, 3).

At the same time, there was a continuing interest in fabrics of contrasting textures (1, 2, 3, 10, 18) and a pronounced taste for dark rich colours and soft heavy materials such as velvet (1) and, especially, plush – a type of cotton velvet with a long pile (8). Jewellery was also important and during the early 1880s there was a vogue for short, thick gold chains suspending heavy medallions (1, 2, 3), alongside the enduring fashion for neck brooches and longer watch chains suspended across the bodice (3, 9, 13, 14, 15, 17).

In around 1883/4 the fashionable line altered drastically with a shortening of the bodice and re-emergence of the *tournure* or bustle, and this remained the height of fashion until c.1887/8, disappearing finally in around 1889. This 1880s bustle differed from the early-1870s version in being generally narrower but more sharply projecting at the centre back, and in its most extreme form resembled a domed bird cage beneath the dress (15, 17). Heavy skirts, worn longer again, fell in folds from the bustle and were often draped, apron-style at the front (12, 15, 17, 21).

By this time, the busy trimmings of the early-1880s had fallen from favour, although heavy figured silks and brocaded or embossed fabrics with plush reliefs were much admired for very formal dresses (15, 16, 17). At the same time, there was an emerging trend towards plainer simpler styles for everyday wear, which featured a very high tight-fitting neckline by mid-decade and, having few adornments, appeared rather severe (9, 11, 13, 14). The 'tailor-made' costume, a masculine-style matching jacket and skirt tailored in plain woollen cloth, also appeared during the 1880s (3) and paved the way for more practical modes of dress for women in the following decades.

By around 1889, as the bustle disappeared, a new fashionable line emerged again, characterised by a plainer skirt. In practice, a small pad was worn around the hips to support the residual fullness (22) while the back now formed a small train. Bodices were still heavily-boned and dipped to a pronounced point at the front, a waistcoat style of bodice being popular during the late 1880s (21, 22).

Fashionable hairstyles of the 1880s are also quite distinctive, for hair was dressed close to the head and usually incorporated a short curled fringe, a feature which had first appeared during the late 1870s (1, 2, 3, 4, 8 10, 12, 14, 17, 21, 22, 23). By the end of the decade styles might still feature the fringe and sometimes appear to be cut short, due to the closely styled hair at the back (21, 22), although the general trend from around mid-decade was for taller hairstyles, the chignon being drawn up higher onto the head (11, 12, 13, 14, 15, 16, 17). At the same time neat, taller caps and hats were adopted to complement the changing hairstyles (15, 18, 23, 24).

Men's dress followed the slender lines which were established during the 1870s. Lounge suits were becoming increasingly popular and are seen most often in photographs (4, 9, 10, 11, 19). Typically, narrowly-cut lounge jackets were single-breasted, fastening with three or four buttons, and the wearing of a white handkerchief in the breast pocket became widespread during the 1880s, offering a dating clue (10, 11, 19). Often the jacket was worn open, or partially undone, revealing a waistcoat with small lapels and featuring a

watch chain, the watch tucked into the waistcoat pocket (4, 10, 11). Trousers were also narrow in cut during this decade, often measuring as little as 18 inches at the knee and hem (4, 10, 11, 19, 20). A more dressy and stylish alternative to the lounge suit was the morning coat (20), which presented a very slender elegant, appearance.

Neckwear varied during this decade but collars were beginning to rise again and the wing collar was the most popular style, accompanied either by the long knotted ('four-in-hand') tie, or versions of the bow tie (10, 11, 19). The neckline was relatively unimportant during the 1880s, however, due to the fashion for buttoning the jacket and waistcoat high at the neck.

Men's hair was short and often worn with a side parting, while facial hair ranged from full beards and moustaches (4, 18), to bushy 'mutton-chops' side whiskers (11), to neat moustaches, often the preference of younger men (10, 20). Hats were still worn in public, the bowler hat accompanying both lounge suits and morning suits (10, 20), while other fashionable accessories included the cane or walking stick (19, 20).

In around 1880, the styling of young girls' clothing finally caught up with the contemporary, sheath-like silhouette of adult dress. Consequently girls' dresses of this decade demonstrate a new narrow shape and are typically quite short, worn to around knee level (4, 5, 7,18). Decorative detailing often echoed that used for women's garments, providing closer dating clues (5, 6). Black woollen stockings were becoming more popular for girls (4, 5, 7, 18). Hairstyles also changed during the 1880s, in keeping with the narrowing of the silhouette. The ringlets of earlier decades gave way to long straight styles left loose or secured behind the head (4, 5), while very young girls adopted the fashionable fringe of the period (5, 6, 7, 18).

For boys, the woollen knickerbockers or shorts suit remained a firm favourite, either styled like a miniature man's suit (4, 18) or made in the sailor style which had become fashionable during the late 1870s and reflected both the growing popularity of seaside holidays among the Victorian middle classes, and national pride in the British Navy, proudest symbol of imperial rule. Based on the standard British naval uniform introduced in the 1840s, boys' sailor suits varied in detail but typically incorporated nautical features such as the loose sailor blouse with broad collar and sailor cap (18).

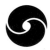

These fashionable daytime outfits all demonstrate the narrow, sheath-like silhouette carried over from the 1870s but the shorter hemlines are typical of the early 1880s. The dresses are ornamented with a profusion of modish pleats, bows, gathers and ruches. All the young women wear their hair dressed close to the head, with the short curled fringe of this decade, while their round, so-called 'picture' hats with brims are also characteristic of the early 1880s.

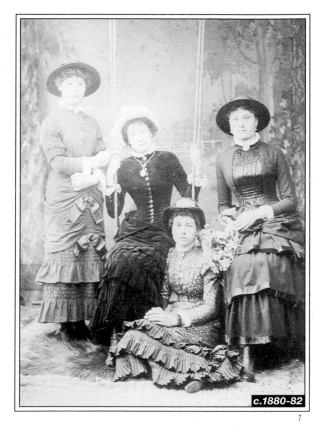

c.1880-82

1

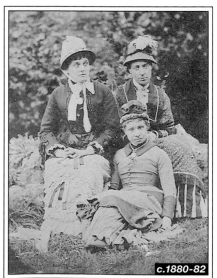

c.1880-82

2

This tintype is typical of the outdoor photographs being taken by itinerant photographers. The principal dating clue is the elongated, tight-fitting *cuirass* bodice with narrow sleeves (seen best on the woman seated in front), and the women's complex skirts layered and pleated or smothered in trimmings. The woman in front wears a soft cap or *toque* (a type of hat without a brim), a style popular amongst younger women during the 1880s.

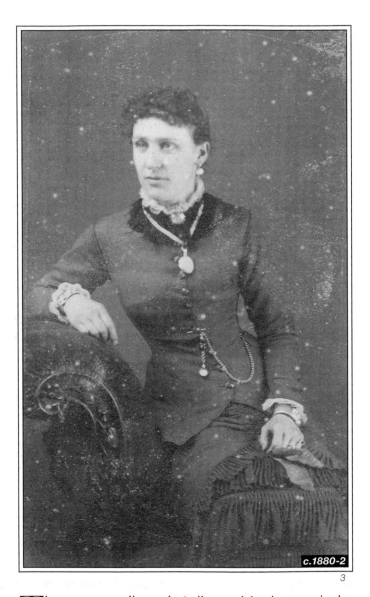

c.1880-2

3

The new, masculine-style 'tailor-made' suit comprised a plain jacket and matching skirt or dress tailored in woollen cloth. The close-fitting, tight-sleeved bodice is complemented by the customary white frill at neck and wrists, while the skirt has layers of fashionable gathered flounces. The short, thick, gold chain suspending a heavy medallion is typical of the early 1880s.

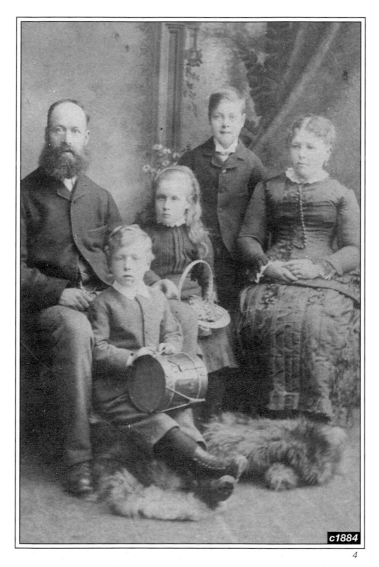

c1884

4

This photograph is closely dateable from the known birth dates of the children. The mother's silk skirt features fashionable pleats and appears fuller than the sheath-like skirts worn at the beginning of the decade, although she may not be wearing the new bustle which was becoming fashionable around this time. Her husband wears a three-piece lounge suit, and the oldest boy, aged about ten, is dressed to mirror his father. The younger son wears the usual woollen suit – the open-ended style of shorts, worn well over the knee, were common at this date.

The dresses worn here are all slim-fitting, demonstrating the new styles for girls established c.1880. Various decorative details suggest a date in the first half of the decade, in particular the ruching around the necklines and the kilt-pleated skirts.

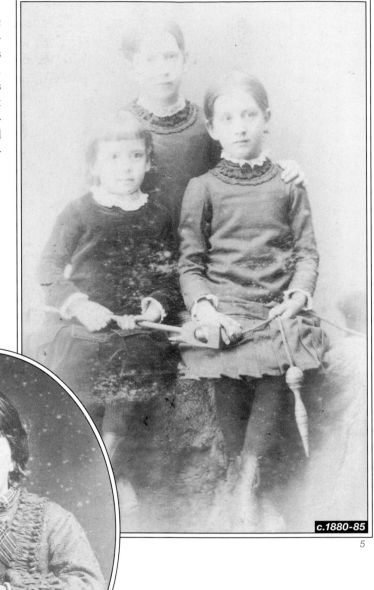

c.1880-85

5

c.1880-85

6

The decorative ribbon at this girl's neck exemplifies the enduring popularity of tartan material, especially in children's dress. Her short hairstyle with a fashionable fringe was popular for young girls at this time.

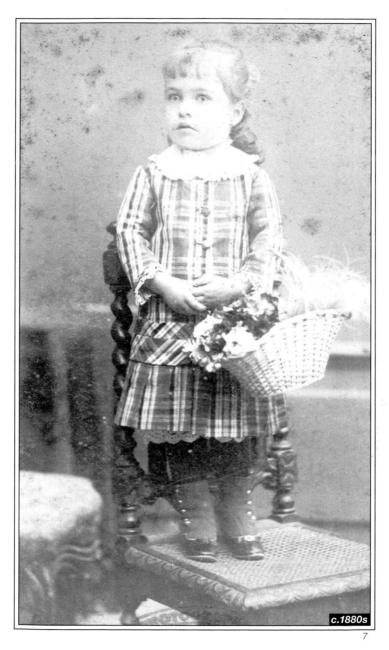

c.1880s

7

Aged around three, this little girl is dressed in her best clothing. The low sash around the hips was a common feature of this style. Typically, the dress is made short, to around knee-length, and here reveals her lace-edged bloomers or petticoat.

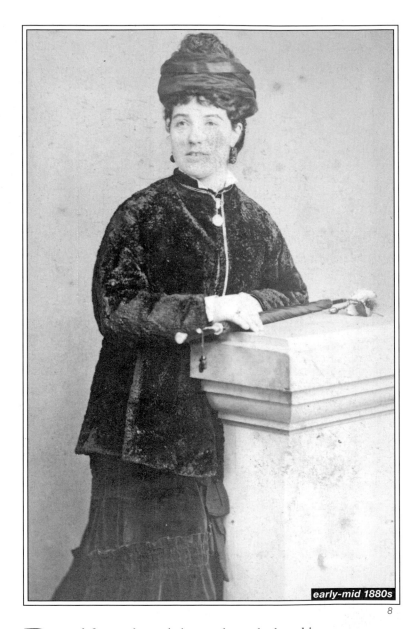

early-mid 1880s

8

Dressed for outdoors, it is not clear whether this young woman is wearing a modest version of the bustle, introduced c.1883, although the sweep of her skirt suggests the lengthening hemline or short train which accompanied the bustle. There was a vogue for short jackets and capes during this decade.

The costumes worn by these women are plain and stark, reflecting the contemporary trend towards more practical, masculine styles for everyday wear, which would also be in keeping with their preference for simpler unadorned garments as devout Christian women, evidenced by their crucifixes. Jewellery is restricted to a businesslike watch chain (*left*), while they all wear neat, severe hairstyles which show little regard for fashion. The man's lounge suit does not closely follow the narrow cut of the decade, the long lapels of his jacket being especially outdated.

c.1883-8

9

This young lady, dressed for outdoors, wears a fashionable tailored jacket over a tight-fitting bodice, with a skirt which incorporates the bustle. She is clearly pregnant here, her buttoned bodice shaped to fit over the bump. Her husband wears a three-piece lounge suit with the usual accompanying bowler hat. His shirt collar is made in the winged style which was most common during this decade.

c.1883-8

10

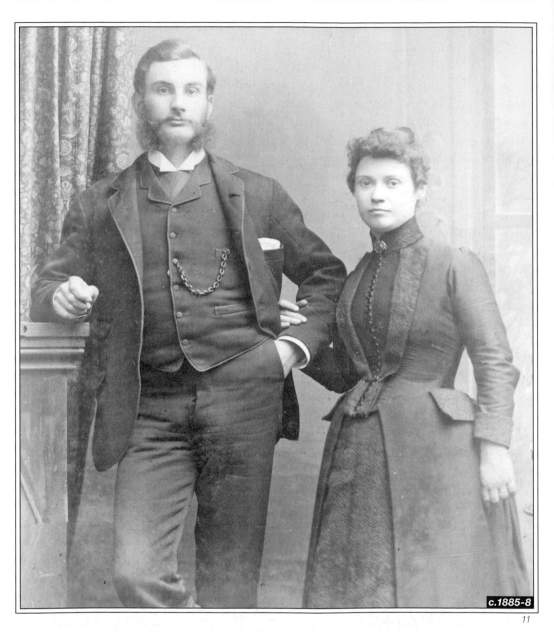

c.1885-8

11

This lady also appears to be pregnant, the open style of her over-dress well suited to accommodating the bump. Her outfit also reveals a large amount of crape fabric, entirely covering the underskirt and trimming her bodice and cuffs, indicating that she is in mourning. Men did not wear such obvious mourning attire as women, but her husband's dull, dark-coloured watch chain also suggests that he is following mourning etiquette, which prescribed that nothing should shine or gleam.

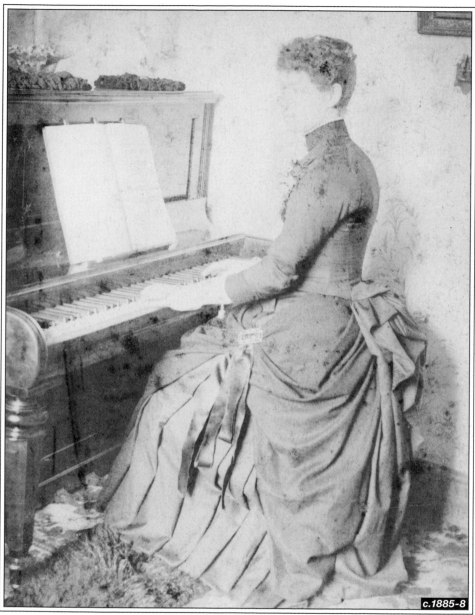

c.1885-8

12

An unusual photograph of a lady playing the piano which offers a helpful side view of the silhouette after c.1883. Her dress is fashionably plain but the complex construction of the skirt is evident, featuring an underskirt of regular kilt pleats and an overskirt draped up at the front and sides, with extra folds of fabric supported by a prominent bustle at the back.

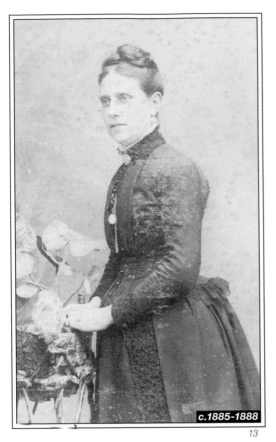

c.1885-1888

13

Black was often worn by mature women, this fashionably plain style being enlivened by lace trimmings and the usual jewellery of the decade. Her hair, piled high into a chignon on top of her head, suggests a date of at least mid-decade when taller hairstyles were becoming fashionable.

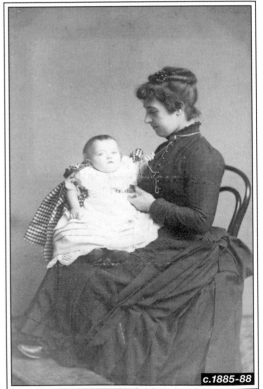

c.1885-88

14

This young mother wears a day dress which typifies the plain styles which were becoming fashionable around this time, her dress of dark cloth featuring the usual narrow sleeves of the 1880s while her skirt is pleated and draped up behind over a pronounced bustle. The high, tight-fitting collar was usual from around mid-decade.

eing a middle-aged lady, or 'matron', she wears a frilled white day cap, its neat shape characteristic of the taller styles in headwear which were emerging during the second half of the decade. Her striking formal outfit reflects the contemporary love of different materials of contrasting patterns and textures, exemplified here by the juxtaposition of bold striped and brocaded or figured velvet or plush

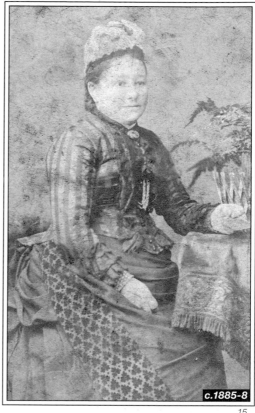

c.1885-8

15

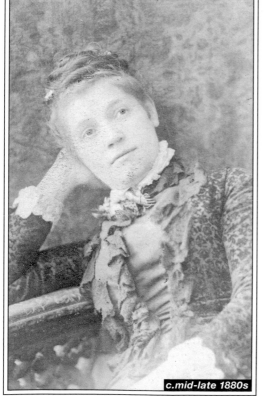

c.mid-late 1880s

16

atterned, textured fabrics such as this, with an embossed or brocaded appearance, were especially popular around mid-decade for formal wear, creating an opulent effect which also reflected contemporary tastes in furnishing fabrics. Her hair, ornamented with a small flower or decorative hair pin, is wound into a high, neat chignon.

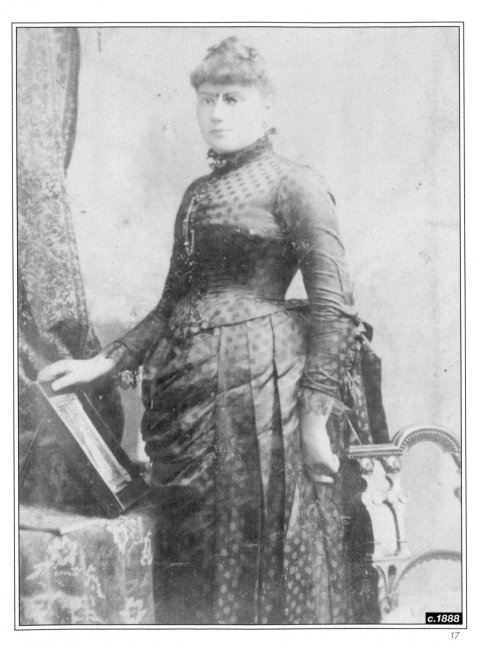

c.1888

17

Born in 1872, this girl looks very young although she must be aged at least 16 to be wearing such a formal adult dress. Her elaborate afternoon dress comprises a close-fitting bodice with a high neckline and extremely narrow sleeves, made fashionably short in the arm, worn with a complex skirt featuring a draped, apron front, side pleats and a mass of drapery at the back supported by a sharply-projecting bustle. The fabric is a rich, figured silk.

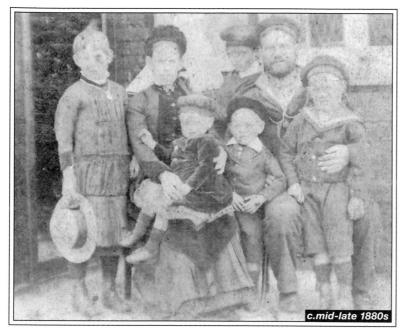

c.mid-late 1880s

18

The father, a professional seaman, wears the regulation naval uniform of the period, his cap and sailor's blouse with distinctive collar and lanyard clearly visible here. The youngest daughter, on her mother's lap, wears a smart coat of velvet or plush, both popular 1880s fabrics. The three sons all wear the standard knickerbockers suit, the boy to the right dressed in the 'sailor suit' version. This photograph was probably taken outside the family home, so may be the work of a professional itinerant photographer.

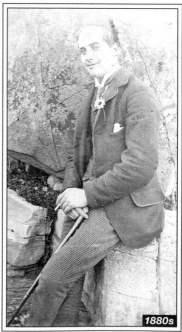

1880s

19

This informal photograph was taken in a natural, rocky outdoor setting. The young man's jacket is, typically, single-breasted with small high lapels, and has a handkerchief protruding from the left breast pocket, a fashion established during the 1880s. He poses with a cane or walking stick, the cane being a fashionable Victorian and Edwardian accessory. Unusually at this early date, he has been photographed smoking a cigarette, a habit introduced into Britain following the Crimean War (1854-6). His close-fitting cap looks a little like the 'smoking cap' which some men adopted indoors.

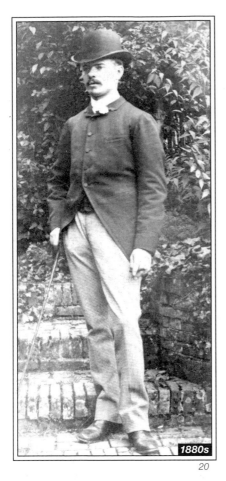

1880s

20

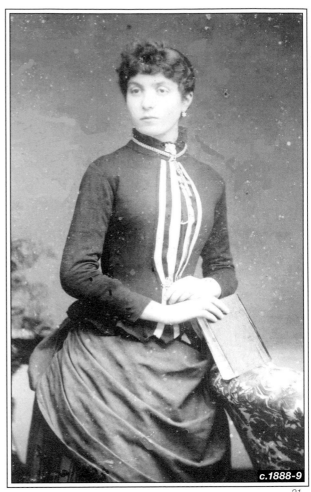

c.1888-9

21

This natural outdoor photograph depicts a young man dressed very stylishly in a tailored morning coat, the usual outfit for more formal occasions by the 1880s and identifiable by its sloping front edges. Worn with contrasting, fashionably narrow trousers, it creates the slender, elegant silhouette which was admired at this time.

This young woman's appearance is closely dateable to the last years of the decade. A principal clue is her skirt, which demonstrates a much-reduced bustle or perhaps the modest padding which was retained to support the residual drapery at the back, following the decline of the protruding bustle in around 1888/1889. The draped style of skirt front, seen here, had also largely disappeared by the end of the decade. The particular form of her fitted bodice, with its masculine-style waistcoat front, was especially popular at the end of the 1880s, and often featured military-style trimmings. Her hair is also characteristic of these years, worn with a fringe and having a very 'modern' short, waved appearance.

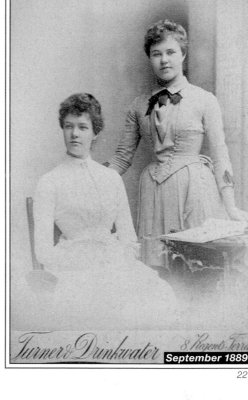

September 1889, when the seated woman was aged 22 and her sister was aged 19. Their fashionable outfits are very closely identifiable with this date. Typically, the bodices are still very close-fitting and extend into the pronounced V-shape at the front, which was characteristic of the end of the decade. By now, the bustle had collapsed, and skirts had lost much of their draped effect, leaving a more natural line supported by a small pad around the hips, as seen clearly here.

September 1889

22

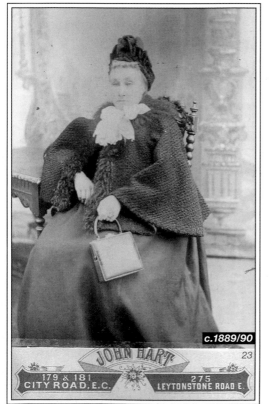

c.1889/90

23

The photographer John Hart's studios at 181 City Road are first listed in 1889, giving an earliest possible date for this photograph. The lady wears either a mantle or, more likely, a *dolman*, which had wide sleeves cut in one with the sides of the garment, making it half coat, half cape. Both were widely worn during the 1880s, when the exaggerated bustle made the wearing of a long coat difficult, dolmans being especially suitable as they were shaped to fan out behind over the bustle. This example is made in a heavy, textured woollen fabric and is edged with fur or a long-piled shaggy wool, both popular trimmings. Her beribboned bonnet is of a style worn only by older women by this time. Her leather handbag represents a rarely-seen fashionable accessory.

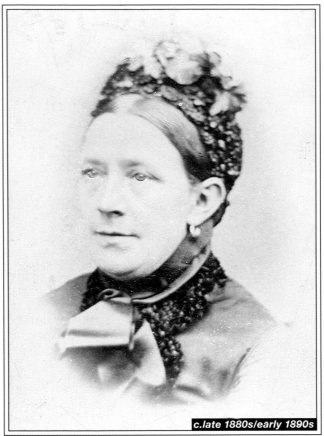

c.late 1880s/early 1890s

24

What we can see of this lady's bodice suggests a close-fitting style, characteristic of the 1880s. It has a striking collar either of black beads or, possibly, of astrakhan, a fur made from closely-curled lambs' wool and which has a shiny appearance in black and white photographs. Both were popular forms of contemporary decoration. Her ornate black cap, decorated with beads and silk flowers, is of a style worn only by older women by this date.

The 1890s

Photographs

In September 1894, the postcard arrived to become the latest popular form of photographic print. The earliest examples usually measured 13.5 cm x 8.5 cm, or 11.5 cm x 9 cm, offering a fairly reliable dating clue. In November 1899 the still common 14 cm x 9 cm postcard became the standard (though not the only) size. Amongst family collections, therefore, a few postcards may belong to the later 1890s though most will be of 20th century date, when it became a standard format for studio portraits.

The carte de visite was still being produced in large numbers during the 1890s, although the cabinet print, which had been slower to catch on initially, was now more common. Tintypes, favoured by travelling photographers operating at fairgrounds, on the beach and so on, were also popular.

Some informal 1890s photographs taken in a natural outdoor setting typically feature amongst images from this decade, but more will still be professional studio portraits. For single portraits the general trend was for the camera to move in closer and so a number of 1890s photographs are head and shoulders compositions. With this style, the practice of 'vignetting' was often applied, whereby the head and shoulders appear in an oval in the centre and the outer area fades away into white (photographs 1880s: 24 and 1890s: 15). Three-quarter length compositions also remained popular during this decade, while full-lengths are much rarer – except for group photographs. Large group photographs were becoming a common theme of the 1890s, commemorating weddings and other family gatherings

In terms of studio setting, backgrounds often appear rather indistinct or blank, although there was a modest vogue for painted backcloths depicting indoor scenes, and when windows are included attention is often paid to the light coming in, producing chiaroscuro effects (12, 19). Props are often limited to a single piece of furniture (4, 5, 13, 14), or perhaps a fence or banister to lean on (3, 17). One of the most obvious features of this decade is the inclusion of exotic palms, either as pot plants or as part of a painted backdrop (1, 3, 6, 10, 18).

Dress

The fashionable female silhouette at the beginning of the decade was defined by a very

close-fitting bodice worn with a plain skirt which initially incorporated modest padding around the hips or at the back to support the residual drapery, following the collapse of the bustle in around 1889 (1, 3).

Sleeves at this time were essentially narrow but featured a distinct vertical puff at the shoulder (2, 3). By 1893, however, the puffed sleeve was expanding rapidly into the full *gigot* or leg-o'-mutton style, a shape characterised by a wide puff in the upper arm, while the lower arm fitted closely. This sleeve style dominated the decade between 1893 and 1897, and is easily recognisable in photographs. Sleeves were at their widest in 1895 and 1896, their width often exaggerated further by a broad collar or other horizontal detailing on the shoulders (6, 10, 11).

Bodices of these years continued to be tightly-boned, to accentuate the fashionable narrow waist, while separate skirts were tailored, with the use of gores, to fit smoothly over the hips before flaring out to a wide hemline (4, 5, 6, 10, 11). The plain, tailored woollen suit or 'tailor-made', first introduced in the 1880s, became increasingly popular for everyday wear during the 1890s, especially amongst 'modern' young women who often teamed it with masculine-looking shirts and ties (8). As always, a more formal dress was elaborately trimmed, creating a fashionably luxurious image (9, 10, 11).

By 1897, the vast *gigot* or leg-o'-mutton sleeves were beginning to deflate and in the last years of the decade sleeves were essentially narrow but generally featured a neat, round puff ball, or gathered flounces or a modest puff at the top (17, 18, 19, 21). Lighter coloured fabrics became popular and, typically, dresses were made with close-fitting, decorative bodices while plain skirts were shaped narrowly over the hips. A more slender, vertical line was emerging. The fashionable silhouette was, at the same time, fluid and hour-glass in appearance, in keeping with the sinuous lines of the emerging *art nouveau* aesthetic taste (17, 18, 19, 21).

Hairstyles of the 1890s, as in any decade, are also a useful dating tool. During the early 1890s the prevailing fashion was for a sleek neat chignon which was usually dressed fairly high on the head (3, 4, 5, 6). From around mid-decade the preference was for softer fuller styles, waved or frizzed and drawn off the face (8, 9, 10, 11), and these sometimes featured a short curled or waved fringe towards the end of the decade (17, 18, 19). Jewellery for much of the decade typically included a brooch at the neck (3, 4, 7, 9, 10, 11) and a long, looped watch chain (5, 6, 17, 18) although these appear less often with the more decorative bodice styles of the later 1890s.

Lounge suits continued to gain steadily in popularity with men during this period, becoming the most usual style of outfit for day wear, hence the three-piece lounge suit features most commonly in 1890s photographs (2, 12, 16, 18, 19, 20, 21). The fit of the suit became slightly easier, compared with narrow 1880s styles, and the lounge jacket was often made quite long. It was usually single-breasted, fastening with three or four buttons, and had flapped hip pockets and a welt pocket on the left breast, which often contained a handkerchief (2, 12, 16, 19, 20). Trousers increasingly featured turn-ups at the hem and it also became more customary to wear centre creases in the trouser legs, following the invention of the trouser press during the 1890s (12).

The formal frock coat, the symbol of Victorian respectability, created a very smart appearance at this time, being well–tailored to fit the body with longer, fuller skirts (13). It

was still the 'correct' wear of the upper, middle and professional classes, but was by now regarded as dull and essentially conservative, having been largely superseded for formal occasions by the stylish morning coat, which usually had a single-breasted fastening with three or four buttons and an outside breast pocket (11).

Neckwear was a significant feature of men's dress during the 1890s and heavily starched shirt collars were worn very high for much of the decade (2, 12, 16, 20). The wing collar was a more formal alternative, often worn with frock and morning coats (11, 13). By the late 1890s, the collar was beginning to be turned down in a more relaxed manner (19, 20, 21). Throughout the decade, the 'modern' long, knotted tie was the most common form, worn with all styles of collar (2, 11, 12, 13, 18, 19, 20, 21), although occasionally a bow tie was preferred (16, 19).

Hair was short and usually parted on the side. Outdoors the head was covered with a top hat for formal occasions (22) and with a bowler hat for everyday wear (20), or, increasingly, with the more casual flat cloth cap (20). For summer, the straw boater was a very popular 1890s style (16, 20). Some men, especially the more mature and elderly, still wore a beard and moustache (16, 18, 19, 20) but moustaches were generally preferred (2, 12, 13, 19, 20, 21, 22). Some young men were beginning to experiment with a clean-shaven look (19, 20) and this was expected in certain professions (14, 15).

The dress of young girls marked a radical departure from the styles fashionable during the previous decade. A new style of smock or yoked dress allowed the fabric to fall freely from yoke to hem, and provided a practical, comfortable garment (18). Just as any decoration in women's dress was concentrated mainly on the bodice, so the yoke of the smock became the focus for extra detailing, while the sleeves followed the fashions of the day. Older girls tended to wear dresses based on the smock but caught in at the waist, bringing them more into line with adult styles (18, 19). Tiny girls also adopted the smock but might be dressed more formally in photographs in a miniature version of adult dress (23).

During the 1890s the fashion for short white socks began to emerge for little girls, as an alternative to woollen stockings, and these were usually worn with lightweight shoes rather than leather boots (2, 23). Girls' hair, once long enough, was drawn back from the face and secured behind the head, the length left to hang naturally down the back or over the shoulders (18, 19).

For young boys, the shorts suit continued as the principal mode of dress, made in a variety of fabrics and styles, including the ever-popular sailor suit (16). Older boys adopted adult suits complete with collar and tie and a handkerchief in the breast pocket (19, 20).

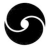

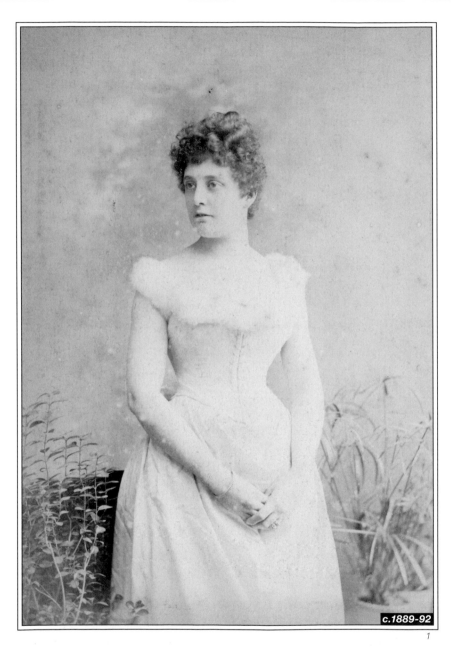

c.1889-92

1

Traditionally, Victorian women's evening toilette differed greatly from daytime styles, being cut low at the neck and usually made with short or no sleeves, leaving the arms bare. White, with its implications of freshness and purity, was thought to be very becoming for young women and this gown, unadorned except for trimmings of white swansdown, would have been suitable for a ball, when light and airy dresses were preferred for dancing.

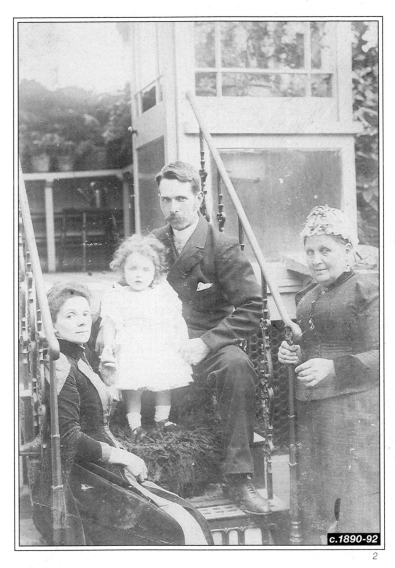

c.1890-92

2

Three generations pose outside the conservatory of their house, the women's dress offering the best clues as to an early-1890s date. The younger woman wears a one-piece dress which may be a maternity dress, judging from the slight bump below her waist, its velvet panels and three-quarter length sleeves being fashionable features carried over from the 1880s. The sleeves are essentially narrow, but at the shoulder the vertical puff of the beginning of the 1890s is just visible.

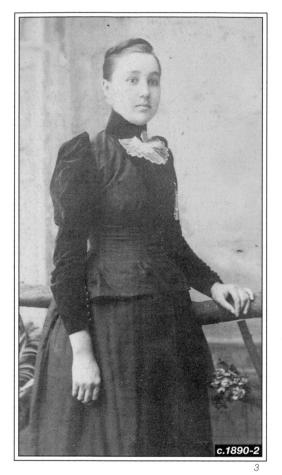

c.1890-2

3

The sleeves are the key to the early-1890s date, for here we see a pronounced vertical puff at the shoulder, a distinctive feature of the first years of the new decade. Other dating clues are the shortened sleeves and frilled white jabot, both throw-backs to the 1880s, and the taste for contrasting fabrics.

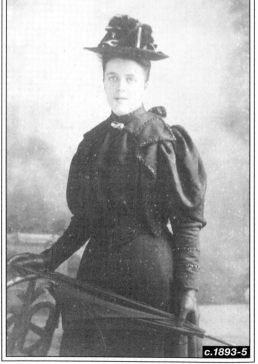

c.1893-5

4

The distinctive sleeves of this smart outdoor or walking costume, made full at the top and narrow on the lower arm, typify the *gigot* or 'leg-o'-mutton' style, fashionable c.1893-1897. Hats were always worn outdoors, this lady's striking black hat, featuring a high crown trimmed with ribbons and a modest brim, being most characteristic of the first half of the decade. Her stylish outfit is completed by black leather gloves and a fashionable umbrella or parasol.

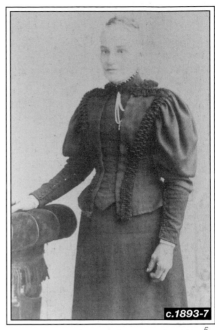

c.1893-7

5

This middle-aged lady wears a good everyday outfit comprising the separate bodice and skirt customary of the decade. Her grey hair is drawn upwards into the neat, high chignon which was fashionable during the late 1880s and early 1890s, the slightly wider date range here reflecting the possibility that she may be a little behind the times.

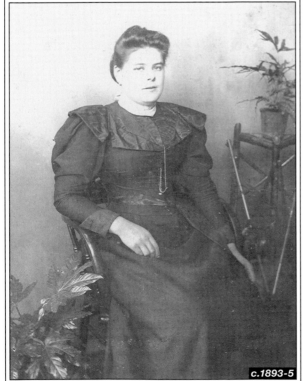

c.1893-5

6

This young woman wears a formal day dress which exhibits the fashionable line of the 1890s, tight-fitting in the bodice, so as to accentuate the waist, and a skirt which flares gracefully from narrow hips to the hem. As sleeves grew wider they were often emphasised further by detailing on the shoulders, as seen by her broad collar of heavy watered silk, which echoes the fabric of her belt and cuffs.

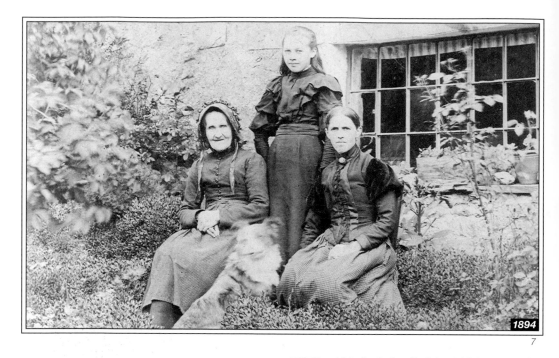

1894

7

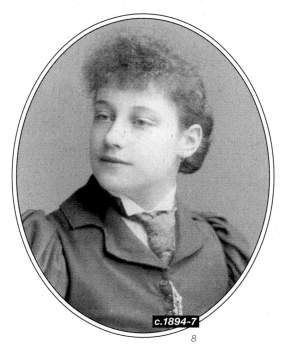

c.1894-7

8

The elderly lady died in 1894, soon after being photographed, so this image is firmly dated. Being country people, they are not dressed very stylishly, although the clothing of the younger woman and girl is dateable to the 1890s from the sleeves. The mother's great-aunt, seated left, has the rather 'timeless' appearance of an old country woman. Her plain, narrow-sleeved bodice is more typical of the 1880s, and her skirt is protected by a large, practical apron. Her cotton sunbonnet is a distinctive feature of rural outdoor dress.

Despite the restricted view, this outfit clearly demonstrates one of the main strands of 1890s fashions – the preference for plainer, practical styles for everyday wear, which was best expressed by the 'tailor-made' costume. The functional business-like image is enhanced by her white shirt worn with a starched wing collar and knotted tie, a conscious adoption of masculine styles.

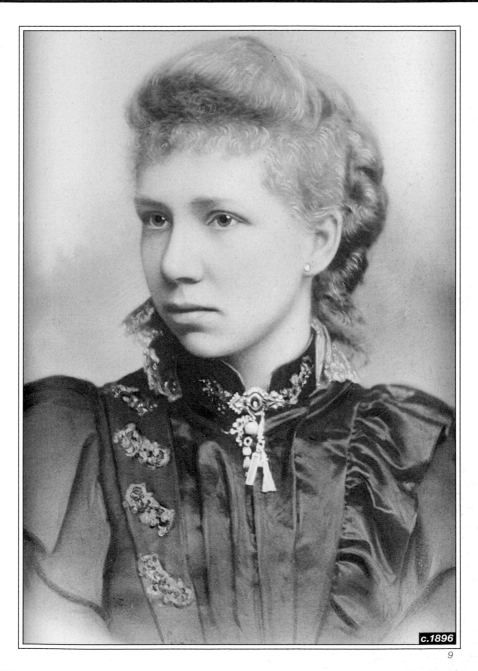

c.1896

9

This young woman was born in 1875, so this may be a portrait commemorating her 21st birthday. She wears a formal satin dress decorated with what appear to be applied motifs or dress jewels, which echo the elaborate clasp and brooch at her neck. Her hair is drawn back, the soft waves becoming fashionable from around mid-decade.

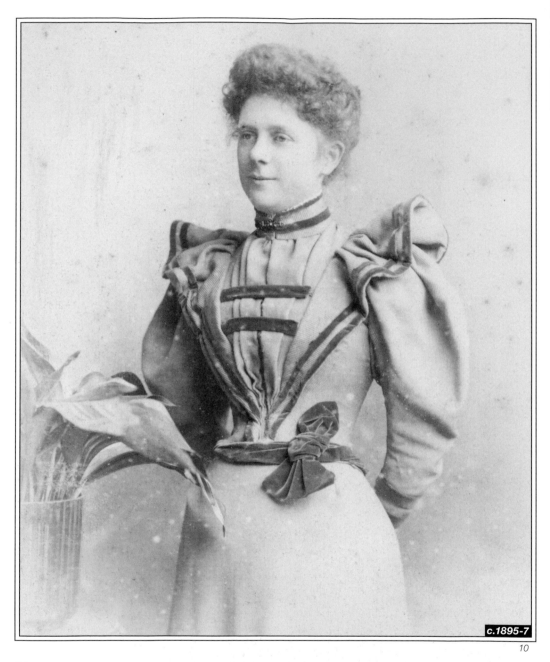

c.1895-7

10

This lady wears a formal day dress which demonstrates the elaborate styles often favoured by mature women, or worn for important occasions. Often the width of the sleeves was accentuated further by fashionable horizontal detailing, exemplified here by her gathered collar, which stands out stiffly over the shoulders.

This couple are wearing elaborate dress, suitable for a formal dinner or reception. The puffing of the lady's sleeves at intervals was not usual, but reflects the Victorian love of historical detailing which introduced a fantasy element into fashionable dress. Her tiny, delicate cap, worn over fashionably-waved hair, was a style preferred for more formal occasions. Her husband is dressed in a formal morning coat, whose cutaway fronts reveal the white waistcoat which was generally reserved for evening wear. His white tie, worn with a starched wing collar, also suggests that he is attired for a special event.

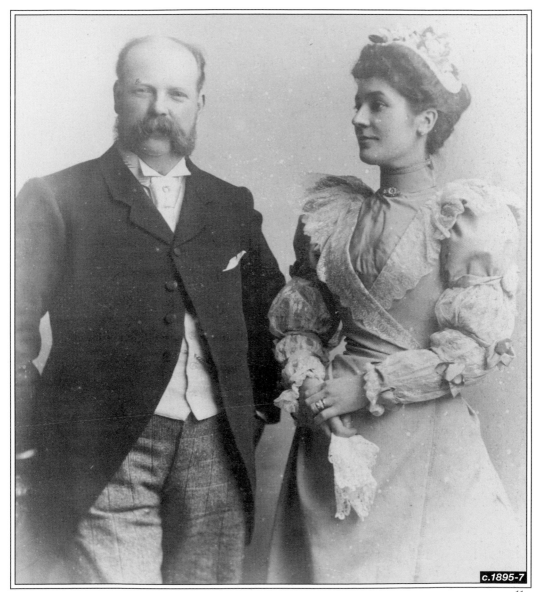

c.1895-7

11

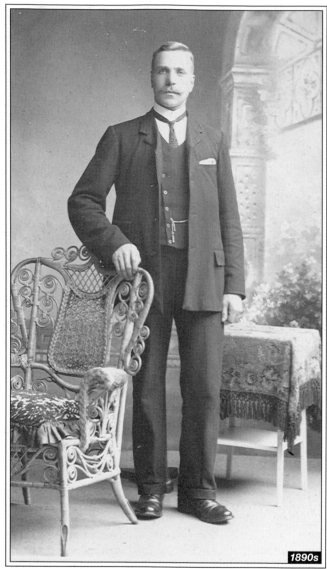

1890s

12

All the features of this man's appearance suggest a date in the 1890s. As was usual, all three pieces of his lounge suit match and they demonstrate the slightly easier fit which was the fashionable style of this decade. His trousers are turned up at the hem and have centre creases, both features which were becoming fashionable during the 1890s.

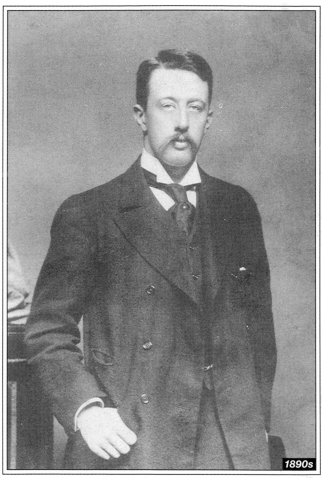

13

This well-dressed young man wears a formal frock coat, identifiable by its long straight fronts, double-breasted fastening with four or six buttons – usually worn open – and the broad lapels of its collar. The frock coat remained a smart and respectable garment, favoured by the upper, middle and professional classes, but was more widely regarded as being rather 'stuffy' by the 1890s.

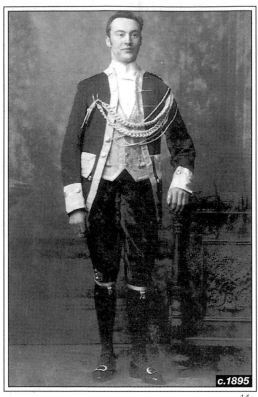

c.1895

14

This young servant at Crookhey Hall in Lancashire, wears footman's livery, which was a 'fossilised' form of dress based on elegant 18th century styles. Significantly, however, his starched shirt collar is made in the high standing style fashionable during the 1890s, offering a helpful dating clue. The elaborate waistcoat, sumptuous velvet breeches and gold trimmings and cords draped across the body suggest that this is either state or semi-state livery, worn only on certain occasions.

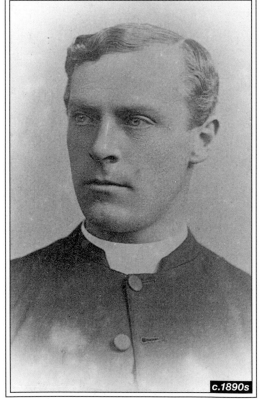

c.1890s

15

This young vicar's distinctive clerical dress is the non-liturgical or everyday clothing worn by members of the clergy, as distinct from vestments which are reserved for church services. The main garment is his clerical frock coat, with its characteristic tabbed collar and large buttons, made to around knee-length or just below the knee. At the neck he wears the usual white clerical collar of starched cotton or linen. He is consciously clean-shaven, as was usual amongst the clergy, at a time when most fashionable young men wore prominent moustaches. It compares well with other dated 1890s photographs of vicars, so, combined with the popular 1890s oval vignette composition, a date in this decade seems likely.

This family is well-dressed for a summer outdoor occasion. The mother's sleeves are made in the full bishop style with deep, close-fitting cuffs, a shape which was fashionable during the 1890s alongside the full *gigot* sleeve, and was especially popular for lightweight blouses. Her straw summer hat trimmed with ribbons is typical of this period, and her white parasol was a fashionable accessory. The father's straw boater reached the height of its popularity during the 1890s.

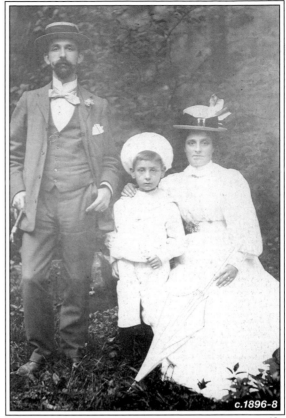

c.1896-8

16

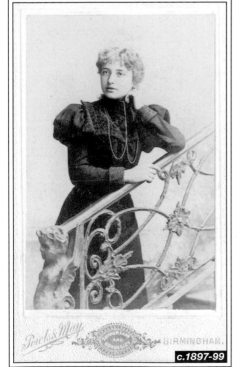

c.1897-99

17

Black clothing does not necessarily always signify mourning, but the dull fabric of this dress and the distinctive crape trimmings on the collar and cuffs confirm this to be the case here. Most mourning photographs tend to depict elderly widows, but young widows or women mourning the death of a parent, child or close family member also followed the prescribed etiquette. The picture is dateable from the puff-ball sleeves, the late version of the 'gigot' sleeve.

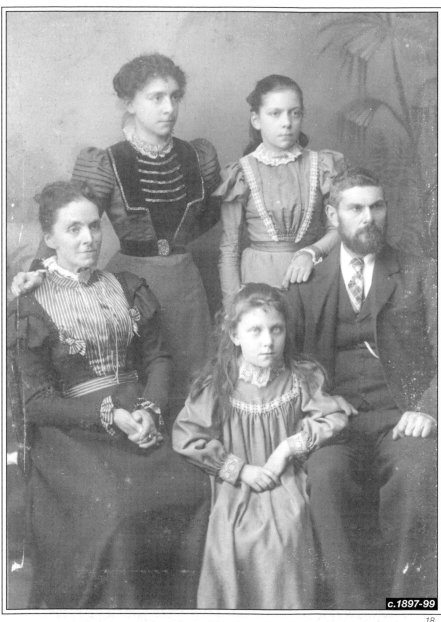

c.1897-99

18

This group photograph is dateable from the women's clothing to c.1897-99. The mother, eldest and middle daughter all wear formal day dresses, their narrow sleeves featuring either a pronounced puff ball or a small residual puff at the top which demonstrate the leg o' mutton sleeve in its final phase from around 1897. The youngest daughter wears a smock or yoked dress, an 1890s innovation.

The narrowing of sleeves created a more vertical, fluid look, matched by the slender lines of the women's formal dresses, made with close-fitting bodices and skirts shaped narrowly over the hips before sweeping outwards towards a wide hem. As usual, all decoration is on the bodice, various types of trimming producing a V-shape or square yoked effect. The younger women's hair is fashionably frizzed, and worn with a short, curled fringe, typical of these years.

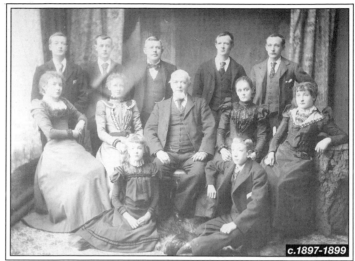

c.1897-1899

19

This group of men and boys pose outside their workplace, presumably a family business. The importance of outdoor headwear is demonstrated here, most of the men and a boy wearing the flat cloth cap which had become the trademark of the late 19th and early 20th century working classes. The rather 'snappily' dressed man in white sports a distinctive Homburg hat. The more formal bowler hat worn by the man to the left of centre indicates that he is the company manager. Most of the men wear prominent moustaches, as was fashionable during the 1890s and early 1900s. The only beard is seen, typically, on the elderly man in the centre, who is probably the owner.

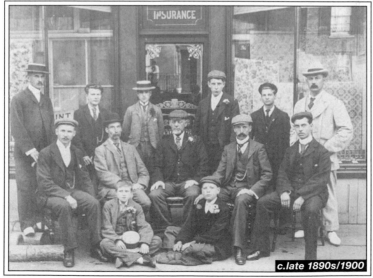

c.late 1890s/1900

20

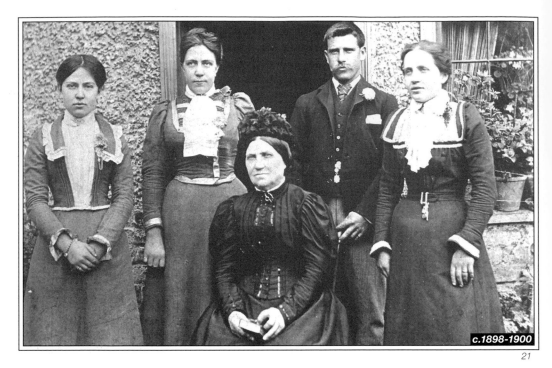

c.1898-1900

21

The flower buttonholes worn by the younger members of this group suggest a special occasion, perhaps the mother's birthday. The younger women wear good day dresses, whose slender figure-hugging lines demonstrate the emerging hourglass silhouette. The older lady, probably a widow, wears an old-fashioned separate bodice with puffed sleeves and full skirt, and a decorative black cap, in keeping with her age. The man's turned-down shirt collar, worn with the 'modern' knotted tie, was becoming fashionable around this date.

c.1898-1900

22

The bride's long, trailing bouquet of loosely-arranged flowers and foliage is typically late-Victorian/Edwardian in style. Brides often wore elaborate hats rather than veils at this date, since the current vogue was for vast, wide-brimmed hats decorated with a profusion of trimmings including ribbons, flowers and feathers. In honour of the occasion, the female guests (with the exception of the conservatively-dressed elderly lady, right, who wears a frilled day cap), all wear equally impressive hats.

c.1898-9

23

This little girl was born in 1894. Coming from a well-to-do family, she is very well-dressed in a white summer outfit comprising a short jacket and matching skirt which reflect contemporary women's suits or 'tailor-mades', but are looser in cut. The short white socks were becoming a firm favourite for children's summer wear during the 1890s and complement her white leather shoes. Her perfect outfit is completed by a miniature pair of white gloves.

c.late 1890s/early 1900s

24

Photographs of babies are notoriously difficult to date closely and the studio props used here are more helpful in this respect than the dress. The wicker couch with its ornate scrolled back and the fabric of the cushions, characterised by bold motifs in the *art nouveau* style, both suggest a date around the turn of the century. This is supported by the shaggy fur rug, a prop which was first used for photographs of babies during the 1890s and remained popular during the Edwardian period.

Photographs

As we enter a new century, as well as a new decade, there are likely to be significantly more informal or amateur photographs amongst family collections, compared with the 1890s, due to the growing popularity of amateur photography following the arrival of the Kodak Box Brownie in 1900. The Brownie, loaded with a roll film which was returned to the factory for processing, was user-friendly and did not require a high level of technical expertise. Costing five shillings, it was also relatively inexpensive, making photography more affordable for many. Amateur 'snapshots' were always taken in the open air, where the light was. In terms of identification, outdoor photographs are difficult to locate, unless they include a recognisable building or landscape, and so the most helpful visual evidence relates to the appearance of the subject(s).

The enthusiasm for amateur photography did not detract from the work of the commercial photographer but effectively increased the number of photographs being taken at this time. Professional photography continued to flourish and commercial studio portraits still account for a large proportion of early 1900s photographs. The professional photograph was considered superior and, therefore, more desirable, and a visit to the photographer still represented a special occasion for many. The introduction of a new photographic format – the postcard – also helped to ensure the enduring appeal of the studio photograph. Cartes, cabinet prints, and pictures in other sizes were still produced, but postcard photographs had mass appeal and came to dominate the early 20th century. They could be posted, although chiefly they were given, exchanged and collected. Postcard sizes, the style of their backs and – if posted – their postmarks and stamps all provide dateable details.

Studio photographs, because of their contrived nature, offer more visual clues than do outdoor snapshots. Head and shoulders compositions remained popular for single portraits, but increasingly three-quarter length or full-length single portraits were preferred, following the usual style of group photographs. Artificial settings featuring the balustrades and plinths of earlier years are sometimes seen (photograph 4), although indistinct, neutral backgrounds (10, 11,12, 20) or painted backdrops suggesting a wooded glade are more typical of this decade (13, 17). Chairs demonstrate the conventional Victorian and

'rustic' styles, and the new, simpler lines of late-decade which reflected changing trends in furniture design (20).

Dress

The growing diversity of early 20th-century photography renders the evidence of dress even more important as a key to dating an image. At the turn of the 19th/20th centuries, the fashionable female form was slender and vertical, close-fitting garments following the contours of the body to produce an hourglass silhouette (1). The sinuous curves of the prevailing *art nouveau* aesthetic line influenced dress for much of the Edwardian period. Bodices were worn over a new shape of corset made with a long, straight centre-front busk, which effectively threw the bust forward and the hips backwards, producing a characteristic S-shaped stance. Skirts were fluted in shape, to fit smoothly over the hips before flaring out into a sweeping, floor-length hemline. One-piece dresses remained a formal daytime option, but more practical, separate blouses and tailored skirts were becoming increasingly common for everyday wear (2, 4, 6, 7, 9, 21). The stylish 'tailor-made' costume, familiar from the 1890s, which comprised a tailored, masculine-style jacket and matching skirt, enjoyed even greater popularity during the 1900s (3). It became the virtual 'uniform' of the so-called 'New Woman', the forward-looking young woman who, typically, went out to work, pursued outdoor activities such as cycling (21) and walking, and enjoyed increasing social independence.

Edwardian women were, nevertheless, expected to exude a sense of feminine elegance. Formal blouses presented a confection of lace, frills and flounces, made with full, puffed fronts which emphasised the bust (4, 6, 7, 17). Necklines were always worn very high, but changing sleeve shapes can assist closer dating, as can certain styles of dress or blouse bodice. Day dresses were formal and elaborate, featuring a combination of different materials and trimmings (5, 8, 18). Vast hats ornamented with flowers, ribbons, lace and feathers were essential accessories throughout the decade, although their shape and decoration changed over the years, the various styles offering further evidence of date. Edwardian hairstyles were characteristically wide and full, being puffed out and drawn up, often over pads or a frame, or eked out with artificial hair. The built-up hair often featured a centre parting from c.1907 (16, 19, 20). In general, the fashionable image was exuberant and three-dimensional, until c.1908/9 when the curvaceous S-bend silhouette began to give way to a simpler, narrower line and plainer garments featuring less surface decoration, their appearance a key to identifying photographs taken late in the decade (19, 20).

Photographs of men dateable to the 1900s demonstrate a distinct uniformity of appearance and, allowing for the fact that some features of dress drift over between decades, they are generally readily identifiable. By 1900, the standard everyday wear for men was the three-piece lounge suit, worn with a bowler hat (1, 9, 13, 23), or the less formal cloth cap (17, 24), depending upon the wearer and the occasion. Fashionable jackets were cut quite narrow, generally with small, high lapels, while trousers were also narrow and, typically, quite short (7, 8). White shirts featured starched collars, which at the beginning of the decade were often worn standing high, following 1890s fashions (1). However, the more relaxed, turned-down collar, usually made with rounded edges (though occasionally

pointed edges), and worn with the 'modern' knotted tie, became widely established as the preferred neckwear combination of the decade (8, 13-17). Hair was cut short and close to the head and parted usually to one side. Beards were no longer fashionable and were usually reserved for elderly men (1, 2, 7). Younger and middle-aged men generally sported a neat moustache (1, 7, 8, 13-17), although, as in the previous decade, some young men preferred a more 'modern', clean shaven image (1, 16, 24).

Children's clothing of the period generally continued along late-Victorian lines, although certain features are identifiable as typically Edwardian. Young girls' dresses were usually made to around knee-length and were loosely based on the smock shape introduced during the 1890s although they might be caught in around the waist or hips (12). Their long hair was drawn away from the face, leaving the back hanging freely early in the decade (12), but by the later 1900s was, typically, dressed more elaborately, with bows worn to the sides (16, 17). Older girls wore longer, calf-length dresses and left their long hair loose, only progressing to floor-length hemlines and adult hairstyles at around the age of sixteen (13).

For young boys, the woollen knickerbockers or shorts suit was still the prevailing style, either made as a miniature version of the man's suit, when it typically featured a prominent white collar and might be worn with a close-fitting round cloth cap (1, 23) or in the ever-popular sailor style (11). During this decade, the open-ended style of shorts virtually eclipsed the gathered knickerbockers and, at the same time, shorts began to be worn shorter, typically to knee level (as opposed to below the knee), offering a 1900s dating clue. (11). Young people's footwear is often revealed in photographs; boots of this decade usually fastening with laces as the Victorian buttoned style became increasingly outdated (1, 11, 12) while shoes, fastening with straps or laces, are also seen more frequently (1, 5).

Edwardian babies and toddlers are often arrayed in very elaborate clothing in photographs, little girls being attired in vast, decorative bonnets (5, 9,10) although there was also a contradictory vogue for pictures of semi-naked infants (20).

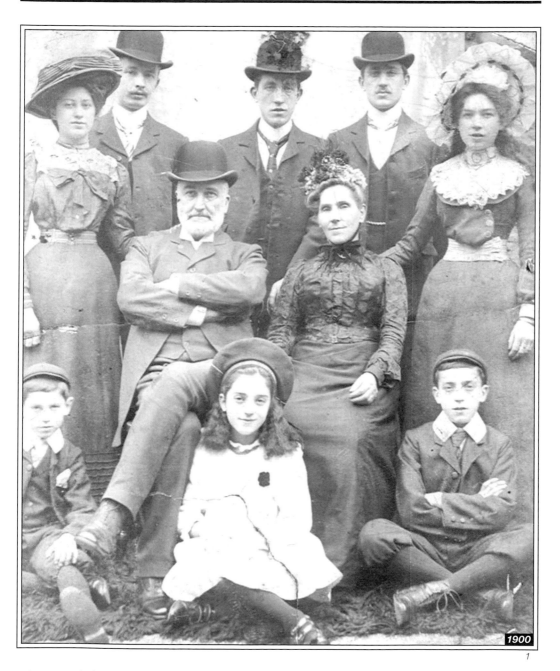

1900

1

As usual in mixed groups, the younger women's clothing offers the best dating evidence in this family photograph: formal day dresses whose slender lines demonstrate the desired hour-glass silhouette; elaborate bodices; straight, narrow sleeves; and plain skirts, made smooth over the hips before flaring gently to the floor.

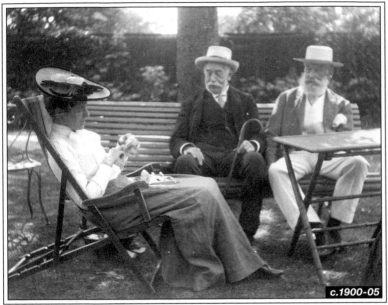

c.1900-05

2

Note the lady's finely-tucked blouse, with the characteristic high collar of the decade, whilst the narrow sleeves suggest a date close to 1900. Her flat straw hat, decorated with shells and other trimmings, is a summer style seen most often in the early years of the decade, whilst the men's high-crowned straw hats represent two of the various styles of summer headwear current at the time.

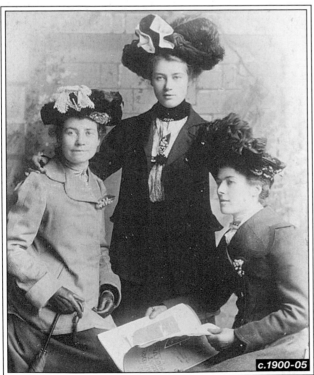

c.1900-05

3

The women in the centre and right of this formal studio photograph wear 'tailor-mades', the stylish, masculine-inspired suits comprising plain, tailored jackets and matching skirts. Underneath they wear the usual high-necked white blouse. Their companion, (*left*), wears a looser fitting, three-quarter length, sac coat – an alternative early 1900s outdoor style.

This studio portrait was probably taken to commemorate the young lady's engagement, judging from the careful placing of her left hand to display the ring on her third finger. Her blouse features the customary high, close-fitting neckline of the decade, whilst the distinctive shape of the sleeves also suggests an early date.

This amateur 'snapshot' depicts three generations of a family, with the clothing of the young woman providing the strongest clue to the date.

The little girl's vast, frilled bonnet is a style seen frequently in photographs of the period.

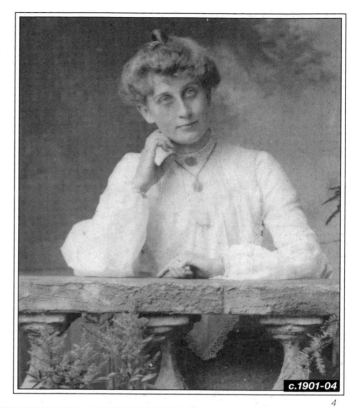

c.1901-04

4

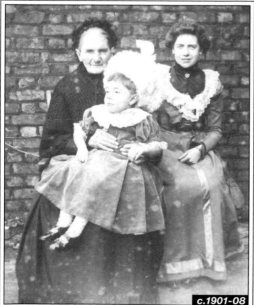

c.1901-08

5

c.1904-08

6

This studio photograph is taken in the oval *vignette* style and the leafy surround is typically Edwardian. The loose, draped front of the blouse, extending over the top of the skirt, indicates a date before c.1909 when a simpler fashionable line emerged. The sleeves and the wide, cape-like collar to her blouse, or *bertha*, offer a closer date. Her broad velvet ribbon decorated with pearls demonstrates the Edwardian vogue for hair ornaments.

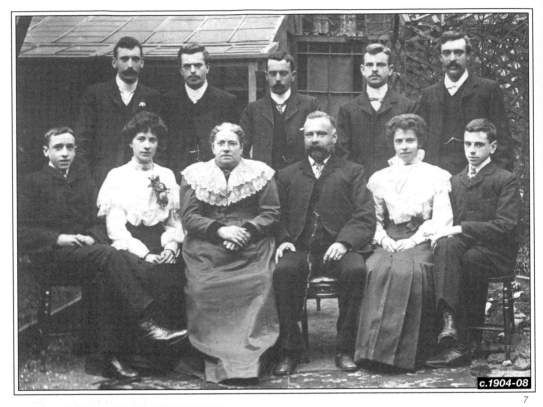

c.1904-08

7

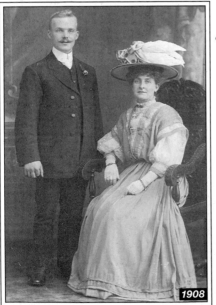

1908

8

Judging from her corsage of flowers, the bride in this informal wedding group is seated second left. Otherwise there is nothing to identify her, since Edwardian brides did not always wear special white/ivory bridal gowns. The bride's mother has a plain, formal dress but wears a decorative, broad lace collar in keeping with current fashions. The men's jackets are cut in the fashionable, narrow style, with small, neat lapels, and the groom is identifiable by his flower buttonhole.

The bride in this picture wears a formal afternoon dress. The bodice comprises alternating panels of lace and fabric, which extends over the shoulders – an arrangement associated particularly with the later 1900s. The groom's narrow, rather short trousers are typical of this period.

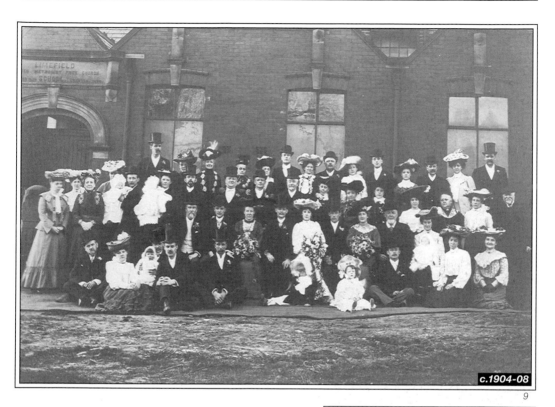

c.1904-08

9

Here the bride wears a white or ivory wedding dress. Bridal gowns invariably conformed to current fashions and her sleeves demonstrate the fullness characteristic of this period. The vast, decorated hats worn by the bride and many female guests also suggest a mid-decade date, and are distinguished by their relatively low crowns, undulating brims and generally flat, wide appearance.

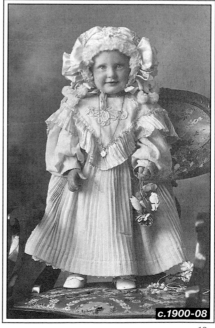

c.1900-08

10

The neutral background of this studio photograph is indicative of the early 20th century, while the toddler's extremely elaborate outfit dates it more closely. Her large bonnet, garnished with frills, bows and pom-poms is especially elaborate.

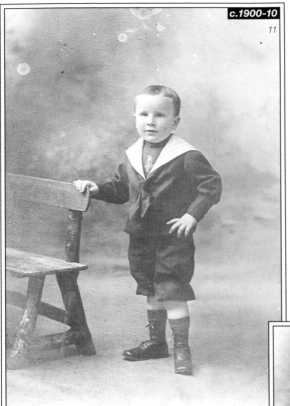

c.1900-10

11

The 'rustic' chair set against a neutral background suggests an early 20th-century date for this studio photograph. The boy, aged probably around four, poses in a version of the popular sailor suit. Note the leather boots, which fasten with laces, rather than the buttoned styles common before c.1900.

The sketchy, neutral background of this studio photograph is typical of the early 1900s, while the girl's appearance indicates a date-range of 1900-08. Her long straight hair, drawn off her face to hang loose at the back, offers a useful dating clue for, later in the decade, girls' hair is often more styled and dressed with bows at the sides of the head. Note also the leather boots, fastening with laces.

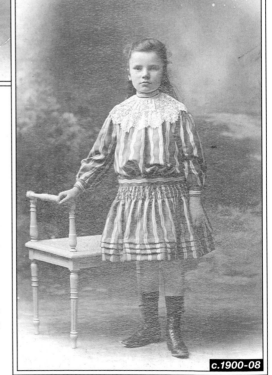

c.1900-08

12

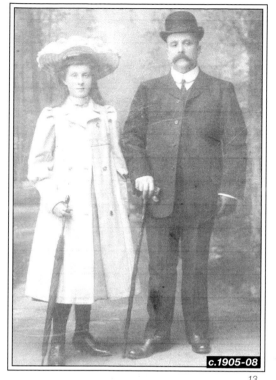

c.1905-08

13

The known dates of the subjects in the picture help with closer dating, for the daughter, born 1892, appears to be aged between 13 and 15 here. This is supported by the style of her outdoor outfit, which is appropriate for an older girl, i.e. shorter than adult garments but longer than young girls' dresses. She wears a fashionable woman's hat in the flat, wide shape of the mid-decade. Her father, aged in his mid/late 40s, holds a cane, still a popular accessory at this time. His jacket is typically narrow with small lapels, and his starched shirt collar is turned down in the manner usual for this decade.

This studio portrait demonstrates all the features of the conventional Edwardian male image: three-piece lounge suit, starched shirt and rounded collar, worn turned down with a knotted silk tie. His neat moustache is most characteristic of the period, although by now some young men favoured a more casual, clean-shaven look.

c.1901-10

14

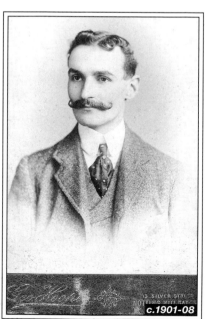

c.1901-08

15

The subject's smart appearance, confirms an early 1900s date, whilst the photographer's details at the bottom of the print offer a further, valuable clue. The starched shirt collar is, as usual, turned down, and is slightly longer and more pointed than the more common styles of rounded collar, therefore appearing rather more 'modern'.

Although the dress details are not entirely clear, the general style is clearly Edwardian. Various bodice styles here, such as the 'ladder'-effect trimming on a dress in the front row and the wide V-neckline of a dress in the row behind (worn over a chemisette), were especially popular later in the decade. Several of the younger ladies' fashionable, built-up hairstyles demonstrate a central parting, which became fashionable from c.1907 onwards, thereby offering another dating clue.

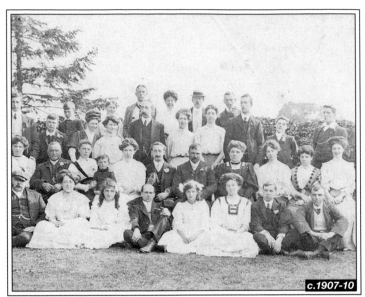

c.1907-10

16

What pinpoints the date of this picture most accurately is the particular style of the ladies' hats, whose crowns appear almost as wide as the brims. They were popular for just a few years between 1907 and 1910. Another dating clue is the young girl's hair, styled in ringlets and decorated with ribbons and bows.

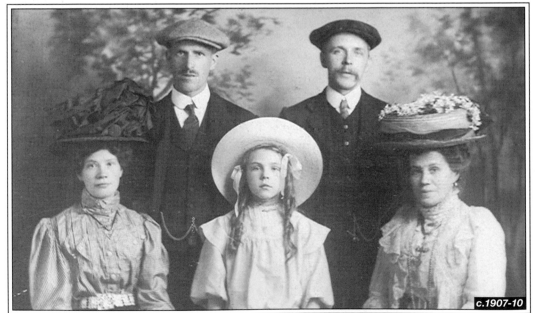

c.1907-10

17

The setting of this studio photograph, with its delicate potted plants, is typically Edwardian and the lady's appearance suggests a date c.1907-1910. Her hair is built up into a thick, undulating ridge over the forehead, a variation on contemporary styles. It is probably dressed over pads or a frame, or perhaps eked out with artificial hair, both common practices during this decade.

c.1907-10

18

c.1909-11

19

The upper panel of the subject's blouse follows a sweeping line extending from the collar over the shoulders in a style which was current for just a few years from around 1909. The general effect is of a clean, uncluttered line, which was typical of these years.

The young mother in this photograph wears a formal afternoon dress whose simple lines demonstrate the new silhouette which was emerging by c.1909 and gives an earliest possible date for this photograph. The toddler's informal, shapeless, machine-knitted vest demonstrates the comfortable, stretchy play clothes which became increasingly popular for young children, especially during the 1910s.

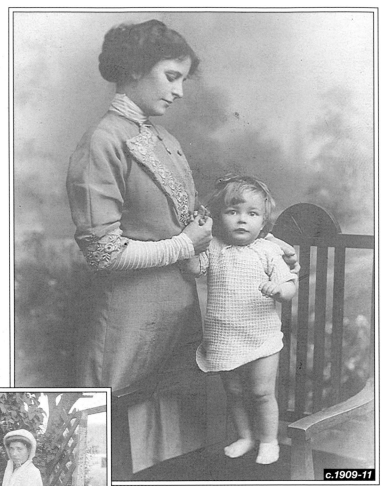

c.1909-11

20

c.1900-10

21

By the 1900s, many active women rode bicycles, the bicycle being regarded as a symbol of women's increasing freedom at this time. Her plain, tailored skirt represents the popular everyday garment of the decade and her cap, similar in style to a man's peaked cloth cap, was a common feature of women's sporting dress at this time. The white veil would be tied under the chin to secure the cap when cycling and help protect the head from dust, much like the veiled headwear worn by women for early 20th-century motoring.

This photograph is broadly datable to the Edwardian period from both the style of the nurse's uniform and from her known birth date, 1868, for she appears to be aged in her 30s here, or, at most, early 40s. It is her armband which narrows the date considerably, for it shows the crossed 'A's and crown of the Territorial Army Nursing Service (aka the Territorial Force Nursing Service) prior to 1920. The Service was established in 1908 and its nurses came to wear an identifying badge, too. The lack of a badge here suggests that it had not yet been issued at the time of the photograph, thus leaving a likely date range of 1908-9.

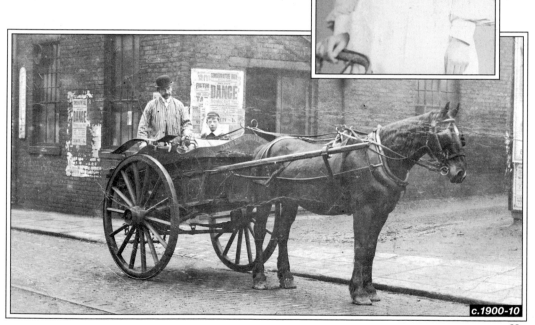

This type of topographical 'snapshot' is typically difficult to date closely and, at first sight, could conceivably be late Victorian or Edwardian. The location may be potentially identifiable, and the man, clearly a tradesman of some description, might be identified from his name, James Eddles (?) painted on the front of the cart. However, the most obvious dating clue is the appearance of the man and boy, which suggests a date in the 1900s. The man's turned down shirt collar is most typical of the 1900s, as is his neat moustache. What we can see of the boy's dress – a round cap and a woollen suit worn with a prominent white collar – accords with this date range.

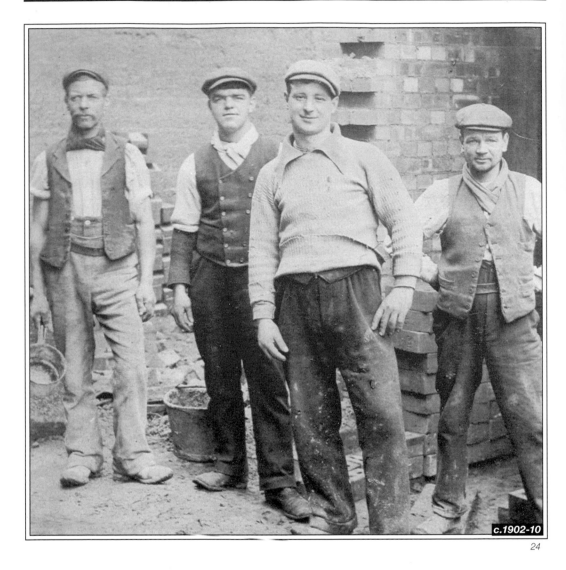

c.1902-10

24

The man on the left in this group of labourers was born in 1862 and died in 1910. He appears to be aged in his 40s here, which dates this photograph to 1902-10. The workmen's garb is typical of the later 19th/ early 20th century, and mostly comprises loose trousers, waistcoats and collarless shirts worn with colourful handkerchiefs or scarves around their necks. Two men wear their shirt sleeves rolled up, one revealing a long-sleeved vest underneath. This was the only sort of situation in which a man might reasonably, at this date, appear publicly in such a state of 'undress', that is, without a jacket, starched shirt collar, or even with his waistcoat undone. The man in front wears a knitted jersey, a casual, comfortable garment, seen more frequently in subsequent years. They all wear the ubiquitous working man's cloth cap of this period.

The 1910s

Photographs

The separations of wartime between 1914 and 1918 were to be a great incentive to photography of all types. Professional studios were continuing to produce photographs in various sizes, and there was a residual demand for early formats including versions of the carte and cabinet print, which fitted conveniently into the remaining spaces in a family's existing albums. However, by the end of the decade there was a noticeable decline in commercial studios, in the face of the growth of amateur photography. Various folding cameras were becoming widely available, including the Kodak Vest Pocket Camera, first introduced in 1912, which became very popular during the First World War.

The main factor which kept studios busy was the postcard format, which was more in keeping with the new age and enjoyed mass appeal. Postcards were at the height of their popularity and were offered not only by professional studios, but also increasingly by promenade photographers operating in seaside towns, and other itinerant photographers, as an alternative to tintypes. Dating clues may be found in the style of postcard backs and by the fact that early images tended to extend to the edge of the card, whereas from around 1915 white borders were more usual.

Professional portraits of this period are still formally posed although subjects usually appear more relaxed than in Victorian and Edwardian photographs, women in particular managing to combine respectability and poise with a more direct, confident expression than previous generations of females. Some photographs taken late in the decade demonstrate their subjects adopting self-consciously casual poses (24). Full-length or near-full length portraits are most common during this period, and photographs of couples and of large and small groups remain popular, weddings being a recurring theme of the years 1914-1918 (13, 18, 19), as is usual at times of war.

Studio settings demonstrate few dateable novelties, backgrounds often being neutral or continuing the sort of backdrops used in earlier years. Clothing, therefore, offers the principal visual evidence of date.

Dress

Fashion during the 1910s responded to wider social and cultural changes, reflecting the decline of the old world that had been dominated by strict rules of etiquette and traditional values, and the dawning of a new era in the aftermath of the First World War.

Women's dress was in a state of transition, as the formality of the Victorian and Edwardian eras gave way, as the decade advanced, to the relatively relaxed atmosphere of the post-war period. Already, by 1910, the frivolous, feminine styles of the 1900s had evolved into a more slender, uncluttered line. Formal dresses often had a draped, high-waisted appearance at this time, in a conscious revival of neo-classical styles (1).

The distinction between the luxurious clothing reserved for evening wear and the more practical styles favoured for everyday wear, suitable for active working women, was becoming more marked during this decade. Consequently, the blouse and tailored skirt combination familiar from the 1900s features frequently in photographs, giving women a smart but businesslike appearance, which was also in keeping with growing calls for female emancipation at this time.

Until 1914, plain skirts appear quite narrow and short, to around ankle length, following the lines of the fashionable 'hobble skirt'. In its extreme form this was so narrow that walking was restricted to a 'hobble', although in reality most women wore their skirt hem at least the width of a stride (2, 3, 4, 5, 6).

Blouses of this period are relatively plain, those of young women often determinedly masculine in style and perhaps worn with a tie (2). From c.1911, the restricting, high-necked collars of the Edwardian period were abandoned in favour of blouses styled with a V-neckline (5), its popularity also extending to bridal wear (4) and tailored day dresses of the period (6). Generally, lower, V-shaped or rounded or more open necklines feature on blouses from 1911 onwards, offering a dating clue (4, 5, 8).

The raised, puffed out hairstyles of the Edwardian period persisted until around 1912, and usually featured a centre parting (1, 2, 3). By c.1913 smoother, more natural styles dressed closer to the head and, worn with a neat chignon behind, were more common (4, 5, 6, 8).

In 1915, women's dress took a dramatic turn, becoming more traditionally feminine, even romantic in style – in order, it is often claimed, that women should appear more attractive to men returning from the Front. The new silhouette, which prevailed until 1918/1919, was characterised by a skirt which flared out from a narrow waist into a much fuller hemline ending several inches above the ankle (12, 14, 15). Both day dresses and more practical separates remained fashionable, V-necklines and collars featuring prominently on bodices, blouses and jackets. Collar styles included the standing 'Medici' collar (12), wide, flat reveres (13, 15) and broad shawl collars (14). Hairstyles became softer again and various shapes of stylish hats were worn, a wide-brimmed, shallow-crowned style being most popular between c. 1917 and 1919 (13, 14, 17, 22).

In 1918 yet a different silhouette emerged, although there was an overlap and the fuller styles of the war years may still be seen in photographs up until 1919. The new, high-waisted line, the skirt billowing out towards a narrower hemline, is often described as 'barrel-shaped' (18, 19, 20). Collars moved towards the back of the shoulders (18, 19, 20) and buttons – both ornamental and functional – remained a significant feature (18, 19,

24). Other developments of the later 1910s which can offer dating clues include a growing preference for shoes over the more traditional ankle boots (14, 20). Generally, fashion was becoming more youthful, more 'modern', and accordingly many younger women were also beginning to cut their hair (13, 15, 19, 20). The soft, short bob was a revolutionary new hairstyle which was to gain wider acceptance in the following decade.

Essentially men's dress changed little during the first two decades of the 20th century, the slender cut of the everyday three-piece lounge suit continuing into the 1910s. Lounge jackets were generally quite long and single breasted, while fashionable trousers were very narrow (often measuring only 17 inches at the hem). In the years before and during the war, men's suits have a rather stark, clean-cut appearance (2, 4, 5, 9, 11, 15, 20).

The turned down collar style, worn with the familiar knotted tie, was the established mode of neckwear (except for formal occasions, when a wing collar was preferred). The starched collar with rounded edges (2, 4, 5, 9) gradually gave way as the decade advanced to a collar with pointed edges (15, 20, 21). This more relaxed style was likely to be unstarched and inspired the wearing of a collar bar – a gold pin which held the points of the collar down beneath the tie, clearly discernible in some photographs taken late in the decade (15, 21).

Inevitably, from 1914 many men appear in photographs wearing uniform of some description (13, 17, 18, 19, 21, 22, 23). Uniforms and insignia provide very specific information about the wearer's rank and role and usually indicate a close date range.

Men's hair during this decade was very short, parted on one side or in the middle. Older men still tended to wear beards, which imparted an air of dignity (2). Younger men favoured moustaches during the early 1910s (2, 5), but were generally clean shaven later in the decade (11, 13, 15, 17, 18, 19, 20, 21, 23).

During the early 1910s, little girls were still wearing full dresses based on the old-fashioned smock (1, 9). Later in the decade a simpler style of dress became fashionable, which typically featured three-quarter length sleeves and a low waistline (15, 16). Short white socks, worn with shoes or sandals, were the most usual style of footwear for this age group (1, 9, 15). Older girls wore garments closer to adult styles, in accordance with their age, teamed with black woollen stockings. Dresses sometimes featured low waistlines from around mid-decade (10) and followed current fashions with their prominent collars and ornamental button trimmings (6, 10).

Little girls' short hair was often styled with a fringe during this decade (1, 15, 16) but once hair was long enough it was frequently drawn off the face and secured with a large bow placed, during this decade, on one side of the head (6, 9, 10, 15).

Boys' clothes were also in transition during this decade, and photographs demonstrate a mixture of old and newer styles. The shorts suit continued as a formal outfit and traditional versions, based on the three-piece suit and worn with a prominent white collar, may still be seen even late in the decade (22). Sailor-style collars also persisted, although they were approaching the end of their fashionable life (10). From around mid-decade, low-waisted jackets and tunics featuring a cloth belt became fashionable, usually teamed with shorts worn now above the knee (14). At the same time, a revolutionary new style of clothing was emerging for boys – stretchy, knitted jerseys and shorts, comfortable outfits which expressed the growing recognition that small boys needed practical play clothes (5).

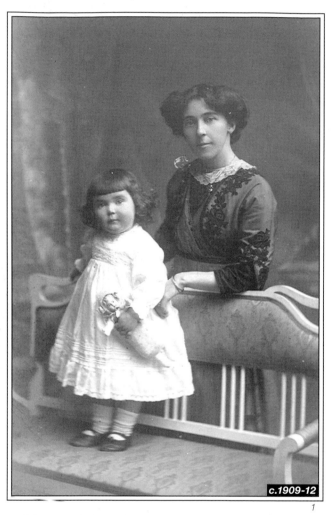

c.1909-12

1

The rounded neckline of this formal afternoon gown is a useful dating clue, as it marks a significant departure from the high, close-fitting necklines worn for much of the Edwardian period. In its most fashionable form, this 'look' was consciously high-waisted, while the cross-over bodice and narrow, three-quarter length sleeves often featured in this draped style of dress. The little daughter wears a decorative cotton dress in the smock-style still favoured for infants at this date.

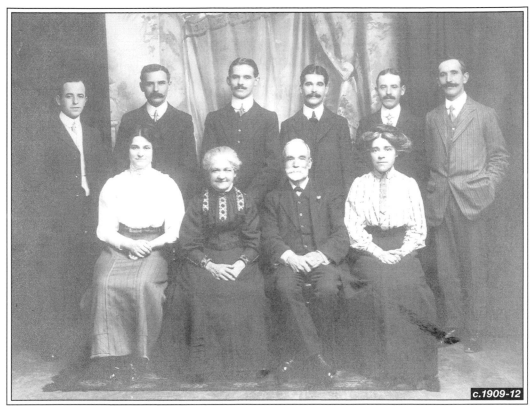

c.1909-12

2

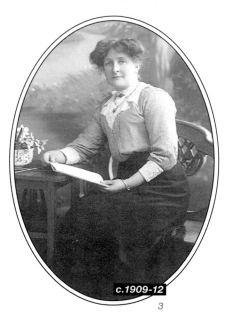

c.1909-12

3

The two daughters are dressed in the everyday women's 'uniform' of a relatively plain blouse worn with a tailored skirt, which is generally narrow in appearance between c.1909 and 1914, the hemline, typically, well above the ground. The younger daughter, right, wears a striped, masculine-style blouse with a collar and knotted tie, a look adopted by mainly young and forward-looking women. The brothers' moustaches are typical of the 1900s/early-1910s and some wear the oiled, centrally-parted hairstyle which was becoming fashionable.

This particular style, comprising a high-necked chemisette worn under a blouse with a flat, lapelled collar, was particularly fashionable c.1909-11. The hair is puffed out and drawn upwards on either side of a pronounced central parting, a style which was in vogue until around 1912, thereby offering a further dating clue.

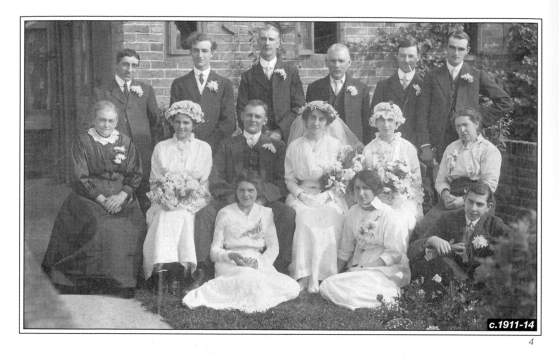

c.1911-14

4

This informal photograph of a wedding group was taken in the back garden of the family home. The bride's white – or more likely, ivory – outfit is dateable to 1911-14, the V-neckline being fashionable from c.1911, while the long tunic blouse, worn over the skirt, was a style associated particularly with these years. The headdress, too, is characteristic, featuring a close-fitting broad cap and short wide veil. Her two bridesmaids, carrying bouquets, are dressed in 'historical' frilled blouses and mob caps – a popular theme for weddings. All the young male guests and the groom wear regular civilian dress, suggesting that this wedding probably took place before the outbreak of war. They wear fashionable, narrowly-cut lounge suits and most favour the round-collar shirts which were still popular early in the decade.

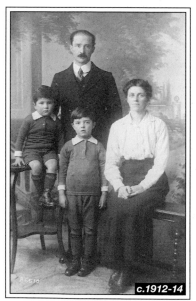

c.1912-14

5

The woman's plain skirt is made fashionably short, to ankle-length, and rather narrow, in keeping with the 'hobble' skirt which was in vogue c.1911-14, while her smooth, neat hair suggests a date of at least 1912. Her husband wears a matching three-piece lounge suit which is fashionably narrow in cut, his slightly rounded shirt collar most characteristic of the early years of the decade. The two sons are dressed in a new type of outfit: comfortable, stretchy knitted jerseys and shorts, worn with 'modern' socks instead of the more traditional black stockings.

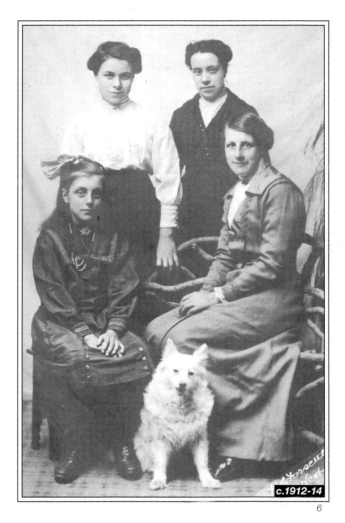

c.1912-14

6

The narrow 'hobble' skirt was at the height of fashion at this time, but, as seen on the right here, most women preferred a more practical version. The younger sister wears a short child's dress featuring a sailor collar, a long-standing fashion which was to die out with the decade. As was usual during the 1910s, her long hair is decorated with a large silk ribbon, worn typically to one side.

c.1910-1920

7

Elderly subjects are seldom dressed in the latest fashions. This layered style of dress with elbow-length sleeves, which reveal a fine blouse underneath, was fashionable c.1909-11. However, she may well have retained this elegant mode of dress through the various changes of the 1910s and so a broad date-range of c.1910-20 seems advisable. She holds a bag whose gathered or pouched style, with a long carrying strap, is typical of the 1910s.

The couple's clothing consciously reflects the photograph's contrived 'beach' setting, being appropriate for a relaxing summer's day at the seaside. The lady wears a comfortable, airy outfit which does not suggest a specific date, but the round neckline was not seen much before 1910. Both she and her husband wear soft white shoes, similar to tennis shoes of the period, which would have been suitable for wear on the beach. He wears an easy-fitting, unbuttoned lounge suit, etiquette still demanding a waistcoat at this date whatever the occasion, although a white waistcoat might be worn in summer. His high standing shirt collar and bow tie are decidedly old-fashioned but were sometimes worn by older, more conservative men.

c.1910-20

8

c.1915

9

Even older men were beginning to abandon the beard, and this man favours the 'modern', completely clean-shaven look. His turned down shirt collar was the usual style for everyday wear, the rounded edges of the collar most typical of the first half of the decade. His granddaughter wears a pinafore over a dress in the smock style usually worn only by little girls at this date, while her white socks and sandals are the most usual style of footwear for young children by this time.

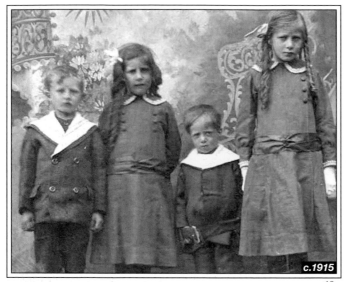

c.1915

10

The dropped waistlines and prominent collars of the sisters' dresses are typical of girls' fashions, while the ornamental buttons were a decorative feature of the decade. The boy's jacket on the left demonstrates the fashion for hip-length styles, his sailor collar still popular in the pre-war period. His younger brother is dressed in a new style of hip- or thigh-length tunic featuring a low-slung fabric belt fastened with a large buckle. The broad collar of his tunic echoes the sailor style, but more generally reflects the 1910s vogue for broad white collars which turned down over the shoulders.

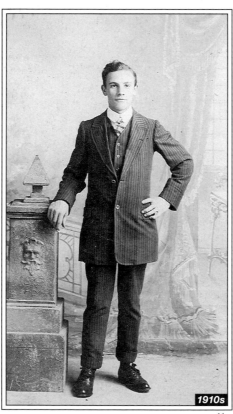

1910s

11

This young man wears a smart, striped lounge suit tailored in the slim-fitting style, which dominated the first two decades of the 20th century. In this helpful full-length view, we see the characteristic long, single-breasted lounge jacket, worn with narrow trousers which were distinctly short in appearance and generally featured turn-ups. His shirt collar has the slightly rounded edges which gave way to the more 'modern', pointed style as the decade advanced. The hair is fashionably short and, like most young men at this time, he is clean shaven.

The young woman's stylish afternoon outfit demonstrates the new silhouette that was emerging in 1915, characterised by a much fuller skirt ending several inches above the ankle. The collar style is a modified version of the popular 'Medici' collar, which often stood high at the back of the neck. Her hair, drawn back and waved over the forehead, reflects the softer hairstyles which were coming into vogue.

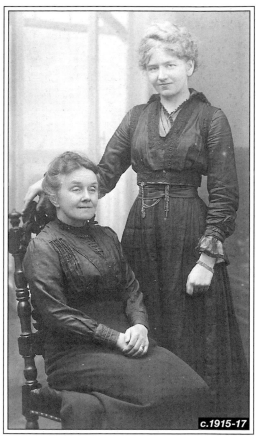

c.1915-17

12

The bride wears a white gown, although during the war brides were often married in civilian dress. Her close-fitting cap and veil, falling wide over the shoulders, are typical of bridal headdresses of this date. The groom and most of the male guests are Australian soldiers, instantly identifiable by their distinctive slouch hats turned up at the side, and their style of service dress jacket. The groom's leather gaiters may indicate that he had a mounted role in the army, for example as a gunner, signaller or animal transport driver.

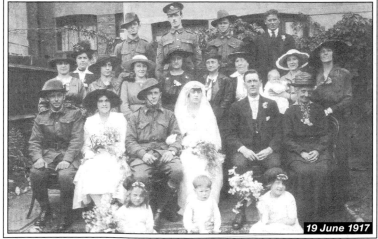

19 June 1917

13

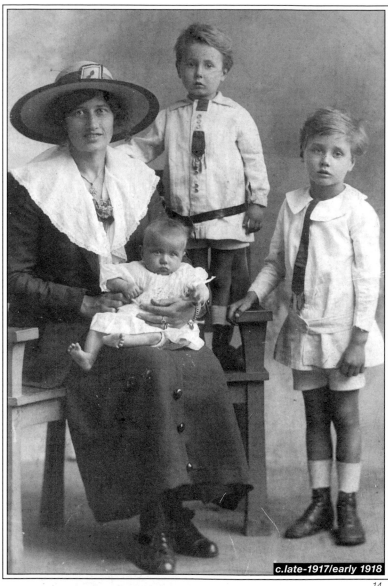

c.late-1917/early 1918

14

The little girl on her mother's lap in this formal studio photograph was born in March 1917. The mother is well-dressed in a plain, tailored suit which is typical of c.1915-18. Collars were an important feature of dress during these years and her fine white blouse with its broad, sweeping shawl collar was a popular style. Her broad-brimmed hat with a shallow round crown was fashionable c.1917-19, while her smart medium-heeled leather shoes demonstrate the growing popularity of shoes as an alternative to ankle boots, during and after the war years.

This studio photograph is firmly dated to 1918. The mother's dress, made with a V-neckline, broad collar and full skirt demonstrates the fashions of c.1915-18, the silhouette beginning to alter again during this year. Her hair is cut short, a revolutionary trend in hairdressing, which more women were following as the decade advanced. Her husband's shirt collar is of the soft, unstarched type which was becoming popular and was sometimes worn with a gold collar bar beneath the tie, as here, to hold down the points of the collar. His hair is cut very short with a centre parting, a common style of the period.

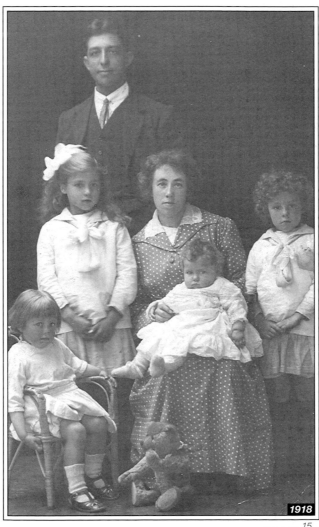

1918

15

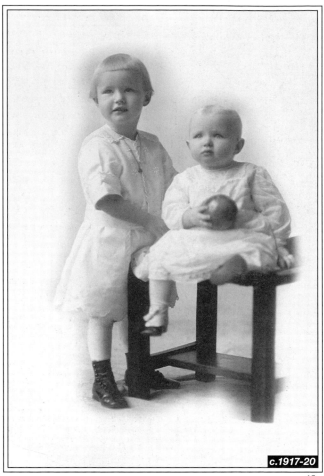

c.1917-20

16

The little girl's simple white dress, caught in at the waist and made with elbow-length sleeves, represents the new styles which were emerging late in the decade. Her leather boots look rather clumsy with this fresh, modern image, although they were still worn during this decade – albeit usually with the more contemporary laced fastenings. Her short hairstyle, cut with a fringe, is characteristic of the 1910s.

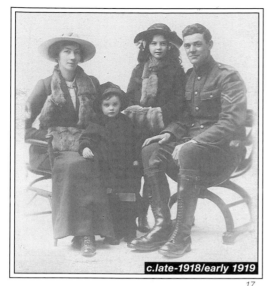

c.late-1918/early 1919

17

The presence of a uniformed soldier in a photograph can offer a very close confirmation of date. Here, the soldier – a corporal, judging from his two stripes – wears a uniform of the simplified pattern without pocket pleats which was usual after around 1917. Its tailored appearance suggests a date just after the end of the war. His regiment is not evident, but his riding breeches and riding boots, indicate he served on horseback. His wife's fur neck stole and muff accord with the fashions of 1918 and 1919, when furs such as red fox and beaver were much in vogue for collars, cuffs and other accessories. Her broad-brimmed hat with a round, shallow crown was especially popular c.1917-19.

This studio photograph probably celebrates the marriage of this young couple, judging from the prominent display of the man's wedding ring. It is dateable to c.1918 from the details of the soldier's uniform, which confirms a date of at least 1917, for his soft cap with a stitched peak was not introduced until that year. His cap and collar badges demonstrate that he was an infantryman with the 5th Battalion of the Northamptonshire Regiment, although his cavalry-style bandolier, the reinforced patches on his riding breeches and his puttees, wound from knee to ankle, indicate his mounted status. The woman's cotton summer dress demonstrates well the new 'barrel-shaped' silhouette which was emerging in 1918, characterised by a high waistline.

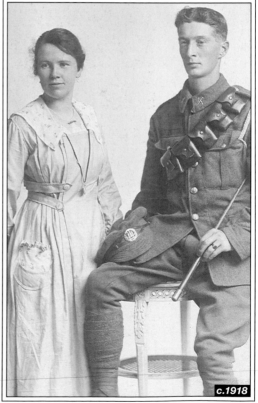

c.1918

18

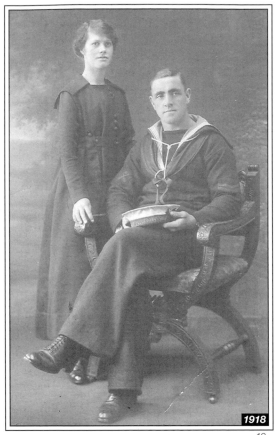

1918

19

This formal studio photograph was taken to commemorate the couple's marriage in 1918. The bride wears a good day dress whose lines reflect the new 'barrel-shaped' silhouette which was emerging in this year, characterised by a high waistline and billowing skirt. The groom, a rating (naval serviceman), wears the standard wartime naval uniform, comprising a blouse with characteristic collar and lanyard, worn over a vest, and teamed with regulation wide trousers. Two distinguishing marks on his blouse provide further information: the badge on his right arm depicts crossed naval gun barrels with a star above, indicating a trade of Gunlayer, 2nd Class, while the two stripes on his left arm indicate not rank but periods of good conduct – in this case 8 years. The ribbon on his cap, sometimes known as a 'cap tally', indicates that he was serving on HMS *Earl of Peterborough*, a 5,900 ton naval monitor built in 1915.

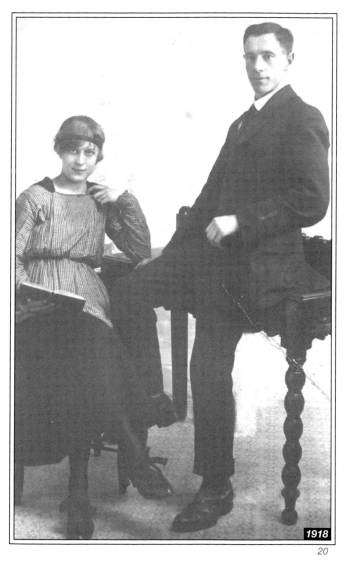

1918

20

This photograph is thought to represent the engagement of the young couple in 1918, judging from the careful placing of the girl's hand so as to display a ring on her third finger. Her outfit represents the very latest fashion for this date, expressed here in a high-waisted tunic blouse worn over a skirt. Other fashionable features are her beribboned shoes and short hairstyle, worn with a stylish headband, very much a young woman's style. Her fiancé also looks very modern and clean cut in the narrow three-piece lounge suit of this decade, his hair fashionably short and his face clean shaven.

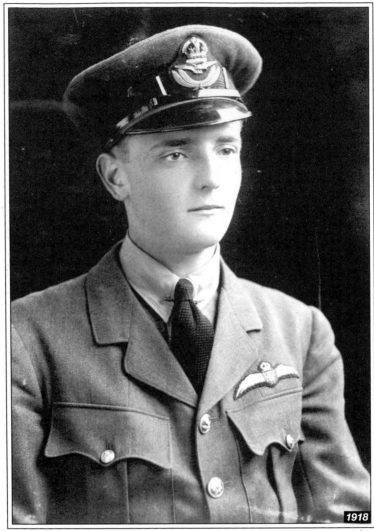

1918

21

The uniform worn by this young man, who was born in 1899, indicates that he was a very early RAF officer. It dates this photograph exactly to 1918, when the RAF was created by combining the army's Royal Flying Corps (RFC) with the Royal Naval Air Service (RNAS). They adopted a distinctive blue uniform and their own badges, including the pilot's wings on the left breast, which bore the letters RAF in the middle. His shirt is regulation grey/blue and the tie black, the collar bar a fashionable accessory which accompanied the soft shirt collar and was tolerated by the RAF. He is an officer – either a Second Lieutenant or a Lieutenant – as indicated by the vertical bar on each side of his newly-introduced RAF officer's cap badge. By July 1918, the RAF had decided on new rank badges and the vertical cap bars were abolished, so this photograph is very closely dateable to the spring/summer of that year.

This firmly-dated street scene depicting the celebrations at the end of the First World War offers a wonderful glimpse of people wearing their 'best' outdoor clothing for a special event. The men, with the exception of those in uniform, wear three-piece lounge suits. Two of them have formal bowler hats, but most men sport either the flat cloth cap, especially popular amongst the working classes, or soft felt hats in the fashionable homburg or trilby styles. Amongst the women, too, only one or two go bareheaded, a reminder of the continuing importance of headwear at this date. Most wear the very broad-brimmed, low-crowned hats which were fashionable c.1917-19, but others wear higher crowned, narrow-brimmed hats, a popular style from around 1918 which continued into the early 1920s.

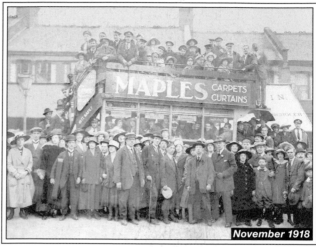

November 1918

22

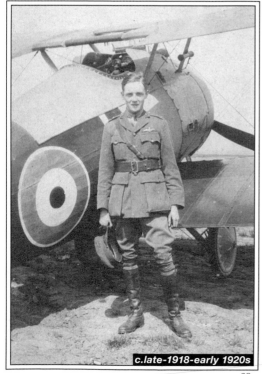

c.late-1918-early 1920s

23

This snapshot of a young airman is undated but details of his uniform identify his role and offer a date-range of c. late-1918-early 1920s. He is wearing the standard British Army service dress for the First World War, but the rank badges on his shoulders confirm a post-war date for the photograph, for during the war rank badges were worn on the jacket cuff. His breeches and riding boots were a popular style amongst First World War officers, whether or not they rode horses, and many retained this mode of dress after the war. His Sam Browne belt was normal wear for all army officers wearing service dress and he holds a standard army service dress cap. Above his left breast pocket is displayed the flying badge for the army's Royal Flying Corps, the RFC having combined with the Royal Naval Air Service to form the RAF in April 1918. His plane appears to be a Sopwith Snipe fighter, introduced into service in September 1918 and used by the RAF until 1926.

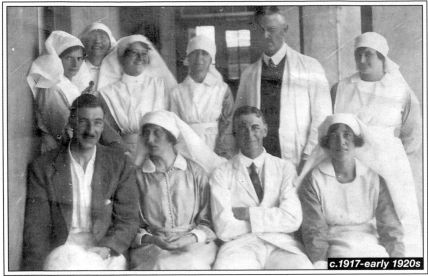

c.1917-early 1920s

24

This informal photograph depicting a group of hospital staff and possibly a patient was taken in Africa. The appearance of the nurses is broadly dateable to the war or soon after. Their uniforms comprise regulation dresses with detachable starched collars and cuffs and enveloping protective aprons, their neat caps with a fall of fabric at the back made in the style associated with this period. Nurses' clothing was generally a conservative version of fashionable dress and the outfit, with its tiny buttons and small collar, worn by the senior nurse second left, front row, would have been fairly stylish during the war years and up until 1920 or so. The man to the left, thought to be a recuperating patient, is dressed very casually, for his unbuttoned shirt, worn without waistcoat or tie, would not normally be considered acceptable for wear in public.

The 1920s

Photographs

A dramatic upsurge in amateur photography is evident by the 1920s, and photographs in the family album are now more likely to be informal 'snapshots' than professional studio photographs. Ownership of cameras grew steadily. Various folding cameras were widely available, but the Box Brownie was easier to use and remained the favourite of most people.

Taking advantage of natural light outside, amateur photographers recorded friends and family posing naturally in ordinary situations, standing outside buildings, sitting in gardens, or enjoying day trips to the countryside or the beach. Users learnt not to point their cameras directly into the sun – so their subjects are often captured squinting into the sun instead!

Large group photographs are also a recurring theme of 1920s photography and depict not only formal weddings and family gatherings, but also classes of schoolchildren, sports teams and members of clubs. Commercial photographic studios did not disappear but they were in decline by the 1920s, their number halving in the inter-war years. Professional photographs were more expensive and less convenient, so a visit to the studio had become a special occasion again, as in the early days of photography. During the 1920s and 1930s the trend was for head and shoulders or short half-length shots, in which close attention was paid to the face of the subject, who was often posed at an angle.

Dress

Because of the diverse nature of 1920s photographs, dress appears more various, often reflecting special uniform styles of clothing as well as more conventional indoor and outdoor garments.

At the beginning of the decade the fashionable line for women followed the high-waisted 'barrel' shape which had emerged around 1918. For daytime, practical blouses and skirts remained popular, worn outdoors with easy-fitting tailored jackets (photograph 4) or with draped coats with prominent collars and capes (2, 3).

Hats of various styles featured moderate brims, worn low over the forehead (2, 3, 4), while younger women were adopting short hairstyles, the hair brought forward at ear level

onto the cheeks, an early-1920s dating clue (1, 2, 3). Between c.1920-22 the position of the waistline dropped to hip-level, obscuring the natural curves, and until 1924/25 hemlines fluctuated between the ankle and mid-calf (1, 3, 4).

By 1925 hemlines were becoming significantly shorter and by the following year fashionable skirts had shrunk to around knee-level – the shortest that they had ever been in the history of fashion. As the skirt shortened, the silhouette began to narrow and to become increasingly streamlined, resulting in the 'flapper' image popularly associated with the 1920s, although this look belongs firmly to the second half of the decade.

The emerging fashions favoured youth, and while young women might be comfortable revealing their legs in knee-length skirts (15, 17, 19), older women often preferred a more modest, calf-length version (12, 13, 14). Nevertheless, for the first time women's clothes allowed complete freedom of movement and the new sense of ease was promoted further by the introduction of soft, pliable jersey-knit fabrics for the so-called 'jumper suits', which provided comfortable but elegant day clothes for active women who wished to look smart but not ostentatious (19).

The uncluttered style of dress which characterised the second half of the 1920s (and echoed the severe angular lines of *art deco* furniture and architecture) was enlivened by prominent jewellery, a long string of pearls becoming an essential item in a woman's wardrobe (12, 13). Other fashionable accessories included a neat clutch bag (12, 14, 17) and shoes made with a single bar across the instep, which fastened with a button, a style adopted by women of all ages between around 1924 and 1930. They were usually teamed with pale, beige stockings, a new development which reflected women's demand for 'flesh'-coloured stockings to complement the unprecedented exposure of the legs at this time (12, 13, 14, 15, 17).

Simultaneously, the deep-crowned, narrow-brimmed cloche hat, worn since the early 1920s, grew more severe in shape and fitted the head closely. This became the predominant style of hat between c.1925 and 1930, and was worn by young and old alike (10, 12, 14, 17). The effect was enhanced by cutting the hair short and dressing it close to the head in flat waves (12, 13, 15, 17,19).

By around 1929, the beginnings of a reaction against fashion's uncompromising lines may be seen in attempts to reposition the waistline of garments to a more natural level (19, 21) and restore some shaping and fullness to the hemline (19). Photographs of late-decade date may also reflect new styles in accessories which looked ahead to the 1930s, especially court shoes (19, 21) and the neat beret, a style of hat favoured by young women (21, 23, 24).

Men's clothing changed little in the years immediately following the First World War. Lounge suits remained narrow in cut, although longer jacket lapels were coming into fashion (1, 3, 7). The vogue for wearing a handkerchief protruding from the breast pocket continued (1, 3, 7, 13, 15, 18), while the watch chain suspended across the waistcoat front was becoming a rarity, generally only worn by older men by now (13), as wristwatches were favoured increasingly over the old-fashioned pocket watch.

Shirt collars were still worn occasionally in the rounded style of earlier years (1) but pointed collars were more typical of the decade and, if un-starched, might, as in the later 1910s, be accompanied by a collar bar (7). Ties were either plain or patterned with stripes,

dots or other small designs (1, 7, 18). A neat tie pin was also a fashionable accessory between the wars (18). Where feet are visible, laced boots may still be seen during this decade (7), although shoes were becoming more popular.

From around mid-decade, a change occurred in the fashionable male silhouette, trousers becoming looser (8, 13, 15), although not everyone followed the vogue for very wide 'Oxford bags', and jackets acquired a squarer, broad-shouldered appearance (18).

Throughout the 1920s hair was very short at the sides, the top either parted and smoothed down with oil or brilliantine or combed back over the top of the head (1, 7, 9, 13, 18, 19, 22, 23). Hats were still widely worn in public, the flat cloth cap retaining its popularity amongst the working classes (11), while a smarter alternative was the felt hat with a dented crown made in either the fashionable trilby or homburg style (3, 8).

For popular sports such as golf, cycling and ice-skating, wide 'plus fours' were worn, fashionable, baggy trousers gathered under the knee, which had evolved from the earlier, narrower knickerbockers. They were usually teamed with woollen stockings or socks and a knitted V-necked pullover worn over the obligatory shirt and tie (23).

Young girls' dresses were generally worn very short during the 1920s, above the knee, and sometimes demonstrate the full, smock shape of earlier decades (5, 22), although simpler, narrower styles were more fashionable (10, 22). Stretchy, machine-knitted fabrics were also becoming popular (6). Short socks were widely worn, either with laced or bar shoes (5, 6, 22), although bare legs and sandals were becoming usual for holidays and beach wear (10). Early in the decade, girls' hair was still dressed in the softer styles of the 1910s, and featured the familiar ribbon on one side of the head (5, 6) but as the 1920s advanced hairstyles were often cut in a more severe bob, echoing women's changing styles (22). Older girls wore slightly longer dresses than their younger sisters, usually with black woollen stockings (16).

The establishment of a school uniform was a significant feature of girls' dress during this decade, characterised chiefly by the gymslip, a sleeveless tunic made with a square neckline and, usually, a box-pleated skirt (6, 20). As their name suggests, gymslips were originally designed for gymnastics, one of the few energetic sports which had been allowed to girls in the late-19th century. Their use gradually spread throughout the school day and by the 1920s they were standard wear in most girls' schools. Schoolgirls of this decade are identifiable by their short skirts, fashionable bar shoes and short, bobbed haircuts (20).

Young boys' dress entered the modern world during the 1920s, as the old-fashioned, formal woollen suits were largely discarded in favour of comfortable, stretchy jerseys, made with buttoned necklines and small collars, worn, usually, with grey flannel shorts (22). A standard school uniform had also developed for older boys (see The 1930s) and even younger boys were wearing shirts and ties (22) and round school caps with a small peak (11).

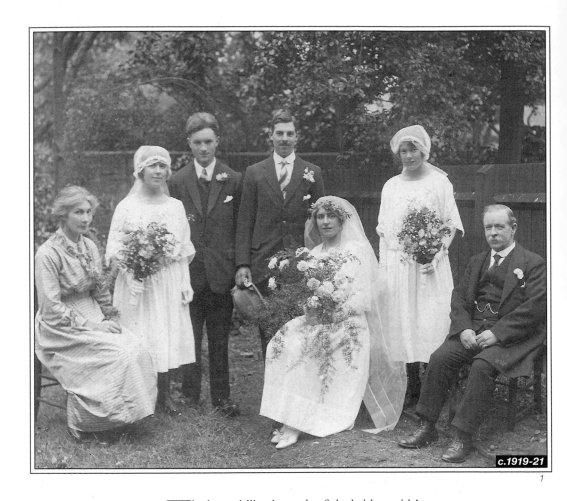

c.1919-21

1

The loose, billowing style of the bridesmaids' dresses is typical of these years, their hemlines made rather short, since they are still young. The bride wears her headdress fashionably low, with the long veil which was favoured at this date, shorter veils being preferred later in the decade. Her white stockings were popular for summer and her dainty pointed shoes, trimmed with bows, were fashionable early in the decade. The bride's mother, seated left, wears a formal silk day dress, its high-waisted 'barrel' shape the prevailing style of c.1918-20.

The head and shoulders composition of this studio photograph and the positioning of the subject, who turns slightly towards the camera, are typical of the 1920s and 1930s. Dressed for winter, she wears a striking, dark outfit which demonstrates the contemporary vogue for rich, lustrous fabrics and soft feathers and furs, monkey fur and sable being especially admired at this time. Her hair, cut short in a soft bob, is also characteristic of the period.

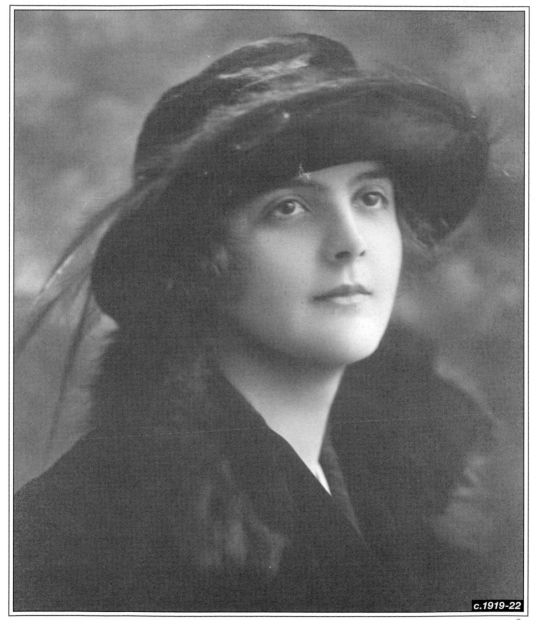

c.1919-22

2

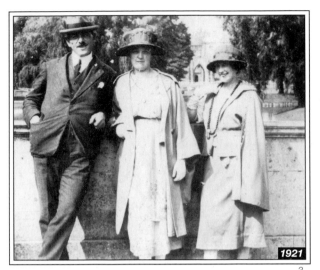

3

Dressed in outdoor clothing, the young women seen here demonstrate the layered, draped silhouette which was characteristic of the early 1920s. The woman standing left wears a fashionably loose, three-quarter length coat made with wide sleeves, long lapels and perhaps a cape attached behind the shoulders. Her friend wears a loose cape over her left shoulder, a popular early-1920s garment, and beneath this a loosely-belted suit whose jacket features a fashionable cape-collar.

The little boy's mother, aged in her early 40s, wears a practical plain tailored suit over a white blouse, still a popular daytime outfit in the post-war years. The jacket is typically fairly loose-fitting. Her high-crowned hat of straw or felt, trimmed here with a striped ribbon, is a practical style, versions of which were fashionable from the late-1910s through to the early-1920s. The little boy's shirt, featuring a broad frilled collar, is rather formal and perhaps a little old-fashioned for this date.

4

c.1919/20

5

The sisters wear dresses made with a smocked yoke, a style familiar from earlier decades, although already simpler lines were coming into fashion for young girls. The short hemline of the older girl's dress is typical of these years, whereas the younger sister wears a longer, more infantile, enveloping dress made with a high neckline and longer sleeves.

The immense gulf which existed between the appearance of the very elderly and the young during the 1920s is demonstrated here. This lady, aged in her 80s, wears a long black dress which bears no resemblance to current fashions, being based on late-Victorian styles. The older girl wears a school gymslip and her younger sister a jersey-knit dress, reflecting the growing emphasis during the 1920s on comfortable, stretchy knitted clothing for young children.

c.early 1920s

6

The casual manner in which the young man's lounge jacket is worn open is typical of a post-war date, when men's clothing was showing signs of becoming more informal. The soft, unstarched shirt collar was also a more 'modern' style, and was often worn with a gold collar bar. His prominent lapel badge confirms a post-war date, for it is the badge of the Australian Returned Sailors and Soldiers Imperial League, introduced in 1919, indicating that he served in the war with the Australian forces. Both men wear laced boots, which gave way increasingly after the war to shoes as the preferred style of footwear.

c.1919-early 1920s

7

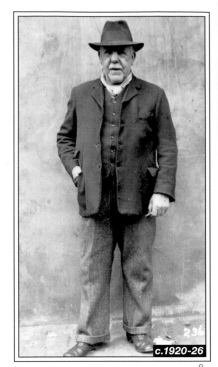

A ged in his early to mid 70s, this man's appearance demonstrates some regard for current fashions but also expresses his own personal sense of style which must derive from his unconventional working life as a successful river-pilot on the River Tyne. He wears the usual three-piece lounge suit, the style of the jacket being rather unfashionable for the 1920s, although the square shoulders are more up-to-date. His choice of neckwear, a cravat, adds a slightly 'rakish' air to his appearance and perhaps reflects his usual working attire, for cravats or handkerchiefs tied around the neck were traditionally worn with collarless shirts by manual workers.

c.1920-26

8

I t can be difficult to date photographs of sports teams closely but in this instance the appearance of the uniformed officer – whose cap and collar badges confirm that he belonged to the Royal Artillery – suggests a date in the early 1920s. The rank badges on his shoulder date his uniform to the post-war period, for before and during the war these were worn on the cuffs. The broad vertical stripes, collarless buttoned necklines and slim fit of the Royal Artillery's football team's shirts are all characteristic of this decade. Their hair demonstrates the 1920s' fashion for very short back and sides, the front combed back over the head.

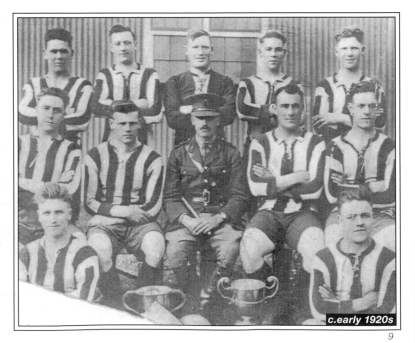

c.early 1920s

9

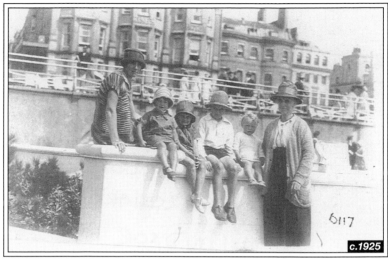

c.1925

As usual in a mixed group, the clothing of a young or youngish woman will provide the best dating clues and the mother here is dressed in a casual, fashionably-striped loose top, probably made from the jersey-knit fabric, which became popular during the 1920s. Her small-brimmed hat, worn characteristically low over the forehead, is an early form of the close-fitting cloche hat.

A charabanc – a type of open-topped bus – was often used for works and church outings during the 1920s and 1930s. It is the headwear which offers the best dating clue, though. The most up-to-date are the neat, close-fitting cloche hats worn by two of the younger women (front row, third right and back row, standing right), which became fashionable c.1924/5.

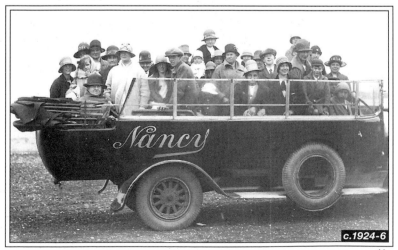

Nancy

c.1924-6

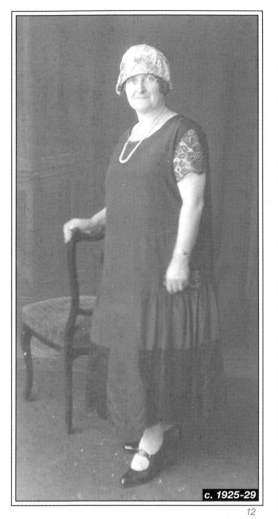

c. 1925-29

12

Born in 1882, the subject is aged in her 40s here but is fashionably-dressed in a restrained version of the 'flapper' look associated with the second half of the 1920s. Her smart afternoon dress, made in a straight, narrow style which obscured the body's natural contours, is typical of these years. On a younger, slimmer woman it would look modishly 'boyish', but her full figure, combined with details such as the transparent sleeves figured in a floral design, her tiered skirt and longer hemline than high fashion demanded create a more feminine appearance. She wears a wristwatch, an accessory which is seen increasingly during this decade.

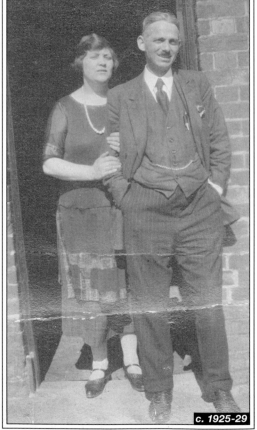

c. 1925-29

13

This informal snapshot depicting its subjects squinting into the sun is typical of photographs taken with a Box Brownie camera. The lady's smart afternoon dress has an outer layer edged with satin panels, which echo those on her sleeves. A single string of pearls was widely worn throughout the 1920s and suits the rounded neckline. Her husband is dressed in a three-piece lounge suit, the cut of the trousers a modest version of the wide styles worn by more fashionable men from around mid-decade.

These women were snapped whilst out on a church event in the Wigan area, possibly 'Walking Day'. Although all appear to be middle-aged or elderly, they are reasonably up-to-date in their appearance, their coats made in the straight narrow style of the later 1920s. The cloche hat of the lady second right is the most fashionable. Several of the women carry neat clutch bags, a popular accessory during the 1920s.

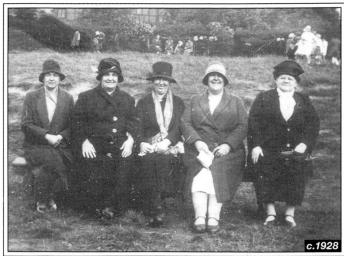

c.1928

14

Traditionally bridal gowns followed fashionable afternoon styles and accordingly wedding dresses dating from the second half of the 1920s were narrow in shape and worn short, to just below the knee or calf-length. The bride's ivory or white dress features the popular round neckline of these years, its skirt made in two layers comprising an outer skirt of lace, worn over a silk slip. Her headdress, decorated with wax buds of orange blossom, is worn low over the forehead, with a short veil of fine net. The bridesmaids' distinctive 'Dutch' style caps, made from machine lace over a wire frame, were highly popular throughout the 1920s.

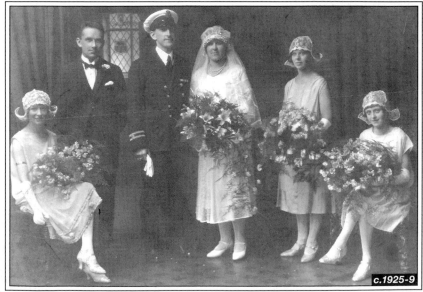

c.1925-9

15

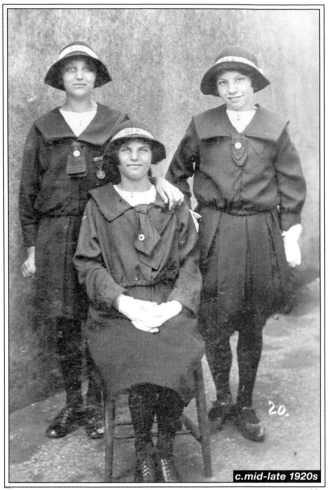

c.mid-late 1920s

16

This photograph, taken in a Portslade studio, depicts three friends from the Girls' Life Brigade. The distinctive white gloves were a regular feature of the GLB uniform, but the precise style of these girls' outfits, especially their short, knee-length skirts, indicates a date of c.1925-1930. So, too, do their brimmed hats, bearing the GLB initials, which are a version of the cloche hat, fashionable between 1924/5 and 1930. Their hair is cut in the short, bobbed style of the later 1920s.

This young woman wears a smart daytime suit comprising a tailored jacket and skirt made in the distinctive narrow, streamlined style typical of the second half of the decade. Contributing to the desirable straight, slender silhouette, which obscured the body's natural curves, are the long lapels and dropped waist of her jacket, the double-breasted fastening echoing men's suit styles of the later 1920s and 1930s. The fashionably 'boyish' image of these years is reinforced by her choice of masculine-style shirt and tie.

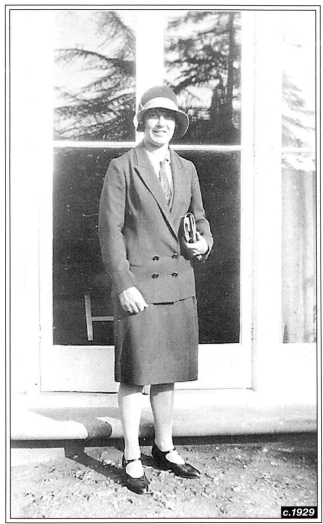

c.1929

17

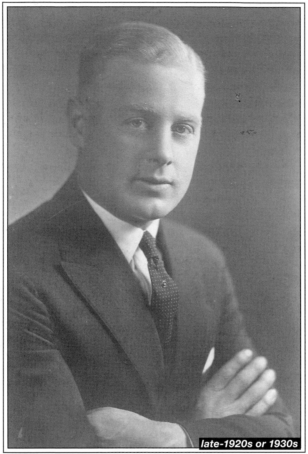

late-1920s or 1930s

18

The square, clean lines of this three-piece lounge suit are typical of this period, which witnessed a widening of the male silhouette. The jacket is tailored with moderately-broad shoulders and wide, flat, sharply-cut lapels, but we cannot see whether it is single-breasted or double-breasted, the latter being more common during the 1930s.

Soft, jersey-knit fabric was widely worn for daytime during the 1920s, due to the combination of comfort and elegance which it afforded. Pleated skirts were especially popular, the fullness of her hemline, ending just below the knee, suggesting a date of at least 1929. Her draped silk scarf, designed in bold contrasting colours, was a favoured accessory during these years while her short, softly-waved hair, worn with a side-parting, is also typical. Women were photographed holding cigarettes more frequently by the later 1920s. Her companion's short hairstyle is very contemporary.

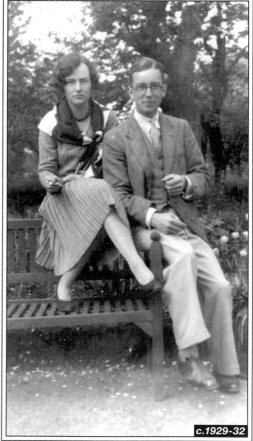

c.1929-32

19

This informal photograph depicting school-girls on an outing to the beach is dated to 1929 or 1930. The general style of school uniform remained largely unchanged for several decades, which can make dating such photographs appear difficult. The main clues here are the short skirts, worn well above the knee, which follow the fashionable hemlines of the later 1920s, and their hairstyles, which are without exception worn in the short 'bob' cuts of these years.

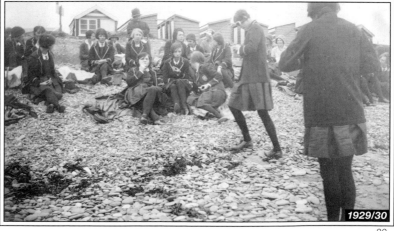

1929/30

20

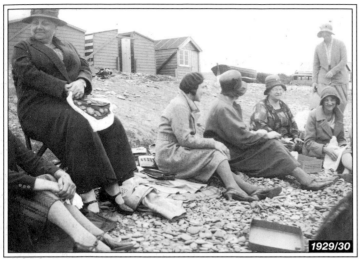

1929/30

21

This group of teachers accompanied the schoolgirls to the beach. The most up-to-date dress for 1929/30 is worn by the young woman facing sideways, centre. Her narrow coat, belted at the waist, demonstrates the beginning of a return to more shaped garments, while her beret was also just coming into fashion at this time and was to become very popular amongst young women during the early 1930s.

1929-30

22

At the time of this class photograph, elementary (modern day primary) school children did not wear regulation uniform. Most of the boys, however, are dressed in what had become a virtual 'uniform' for young boys by this date, comprising distinctive, front-buttoning jerseys with collars and flannel shorts ending well above the knee. The girls' clothing is very diverse, demonstrating the variety of styles current during the 1920s. Several girls wear traditional, smock-style pinafores over their dresses for protection.

Figure-skating enjoyed an enormous appeal during the 1920s and 1930s, largely inspired by Olympic gold medallist Sonja Henie. The young woman here wears a striped skirt which follows the new fashion for short ice-skating garments set by Henie. Her knitted jumper, scarf and gloves demonstrate the vogue for hand-knitted garments during the inter-war years. Her skating partner wears a pair of wide 'plus fours', teamed with woollen stockings or socks and a knitted V-necked pullover worn over the obligatory shirt and tie. The bold, checked pattern of this pullover was, like the Fair Isle, a common design at this date.

This snapshot of the Sheffield United Supporters Ladies' Cricket Team is dateable mainly from the women's short, bobbed hairstyles. There was much controversy at the time over whether women should be playing cricket at all and these complicated gender issues led to conflicting ideas about what women should wear for the game. During the 1920s and 1930s some women adopted the white flannel trousers worn by male cricketers, although knee-length skirts worn with white stockings were the more usual attire. These ladies are wearing short-sleeved, open-necked sports shirts with white flannels, but some wear short skirts over their trousers.

c.1929

23

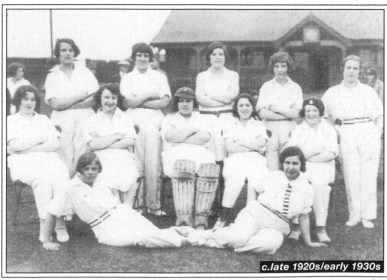

c.late 1920s/early 1930s

24

The 1930s

Photographs

Photographs of this decade may include a few formal poses taken in the professional photographer's studio, but will largely be family 'snapshots' captured with either the Box Brownie (which still only cost five shillings on the eve of the Second World War) or one of the various folding cameras on the market. Both types of camera took roll film photographs and during the 1930s there began to be a shift away from inflammable nitro-cellulose to safety film, while different sizes of film were introduced. The increasing efficiency of 1930s enlargers also meant that the processor could now turn a small negative into a much larger print and, therefore, more images could be fitted onto standard size films. Photography became ever simpler and more cost effective for the amateur.

There will be a wide variety of subjects from this decade – weddings, school groups, people snapped outside their homes, walking in the street, or relaxing on holiday. Photographs also provide a wonderful record of the contemporary interest in healthy exercise and outdoor pursuits. Walking, hiking and rambling were favourite pastimes during the 1930s, offering fresh air, physical exercise and an opportunity to explore the countryside, while camping, hostelling and holiday camps catered for inexpensive, active holidays. Cycling became especially popular early in the decade.

Dress

By the beginning of the 1930s a more feminine look was emerging for women, as clothing began to acquire shaping at the waist and over the hips. Hemlines, although still worn short, to just below the knee, were fuller (photographs 2, 3). Separates, especially in comfortable jersey-knit fabric, remained fashionable for everyday wear, as did pleated skirts (1, 3), while rayon or 'artificial silk' became popular for more formal dresses (2).

By 1932 a graceful and elegant silhouette was established, which, like 1920s styles, highlighted the flatness and slimness of the ideal figure, but in a way which acknowledged, rather than obscured, the natural contours of the body. Dresses from this date until around 1938 were defined by a smooth, fluid line, achieved by cutting material on the bias or cross-grain, which gave it a heightened elasticity and draping quality, while fashionable hemlines plunged to calf-level for day wear (6, 10).

Accessories remained very important. The 1920s bar shoe, still worn in 1930 (1, 2) soon gave way to the plain court shoe, made with heels of varying heights (3, 10, 11, 13, 22, 23). Some very inventive hats were designed during the 1930s. Soft, close-fitting styles such as the beret and other neat hats, worn at an angle, were especially popular during the first half of the decade (6, 10). In keeping with this, hair continued to be styled in a short bob, usually waved close to the head (1, 2, 3, 5, 6, 7, 9, 10, 11, 12).

In around 1934, the shoulder line of dresses and tops began to be accentuated, becoming progressively broader and squarer (13). By c.1938 hemlines had shortened again and an altogether trimmer, more tailored silhouette was emerging, which was to prevail throughout the war years. Femininity was retained, however, through the continuing popularity of floral print fabrics and the vogue for wide-brimmed hats (22, 23).

Other features of dress expressed the sense of glamour which permeated fashion during the 1930s, especially the vogue for fox fur stoles and capes (22, 23), the love of shimmering lamé fabrics for special occasions (11), and a more positive use of cosmetics. New standards of luxury and display, seen especially in glamorous evening dresses and wedding dresses, which swept the floor by the mid-1930s (11), were inspired by the American film industry, which had an enormous influence – between the 1920s and 1940s a night out at the cinema once or twice a week was not unusual and all young women wanted to look like their favourite film star.

There was also a keen interest in swimwear and beachwear during the 1930s. It was acceptable now to bare the limbs and fashionable to acquire a suntan, and this was reflected in new styles of more alluring women's bathing costumes (12). Sportswear in general played a more important role in women's dress during the 1930s.

For work and formal wear, men still wore the three-piece lounge suit during the 1930s, the cut of this decade following the loose, boxy styles introduced during the later 1920s. The square-cut jacket with broad, padded shoulders was usually double-breasted by now, while trousers were wide and generally featured sharp creases and turn-ups. Photographs reflect both extreme examples of this distinctive look (5, 13) and more moderate versions (6, 7, 22, 24). Smart business suits were often tailored in pin-striped cloth (8).

As in the previous decade, narrow silk ties were either plain, or might be patterned with stripes or other small designs (8, 13). Hats were still important for semi-formal or formal wear. The bowler hat was now essentially a city accessory, worn by businessmen, while the felt trilby hat was the most popular style of the decade (6, 13).

The most significant aspect of men's dress during the 1930s was, however, a growing relaxation and informality. Two-piece suits became increasingly popular, while tailored waistcoats were often replaced by pullovers (6). Comfortable knitted garments – waistcoats, pullovers and cardigans – generally featured widely in the male wardrobe at this time (6, 16, 17, 19).

For weekends sports jackets and flannel trousers became fashionable (12, 17, 19). It was also acceptable, for the first time, to forego the tie, and during the 1930s soft-collared shirts were characteristically worn open, spread wide over the jacket collar, as if to celebrate this new-found freedom (12, 17, 19). The growing interest in sport and physical exercise also inspired the development of new, more comfortable, casual styles of clothing such

as short-sleeved, open-collared sports shirts (16). Shorts also made an appearance for men, now that it was permissible to expose the legs, and were enthusiastically adopted for holidays and for outdoor pursuits such as camping, cycling and walking (16, 17). Wide plus fours also remained popular, worn with thick socks and stout shoes (8, 19), while new, casual zipped styles of jacket were introduced as a sporting alternative to more traditional tailored garments (18, 19).

Men's hairstyles of the 1930s were similar to those of the previous decade, cut short at the sides, although younger men especially preferred more casual waves on top to the smoothed-down look (5, 8, 16, 17, 18).

There was a boom in home-dressmaking for adults and children throughout the 1920s and 1930s, many young girls' garments being made by their mothers. Simple, shift styles to just above or around knee-length were popular for everyday wear (15) while elaborate frilled dresses like those worn by the royal princesses, Elizabeth and Margaret, were fashionable for parties and special occasions. Female toddlers wore short, full-skirted smocks, a style which remained popular for many years and can be difficult to date closely (4). Older schoolgirls wore the gymslip, well-established as part of regular school uniform by this time, 1930s dating clues including the length of their skirts, which tended to be longer than during the later 1920s, the styles of their shirts and their hairstyles (5). Girls' hair generally followed the short, bobbed or waved styles which were fashionable for women (5, 15).

Young boys continued to wear the comfortable jerseys and shorts which had become popular during the 1920s, progressing to long trousers or 'longs' in around their mid-teens. This was an age which for many coincided with their entry into the working world, since the school leaving age remained at 14 until 1947, when it was raised to 15. Schoolboys are depicted in photographs wearing the regulation uniform of blazer (based on the adult lounge jacket), white shirt, grey flannel shorts – or long trousers for older schoolboys – and the familiar round, peaked cap (14). The open style of shirt collar, worn without a tie, is also a distinctive feature of boys' wear during this decade, reflecting the new, casual fashions in menswear (5, 14).

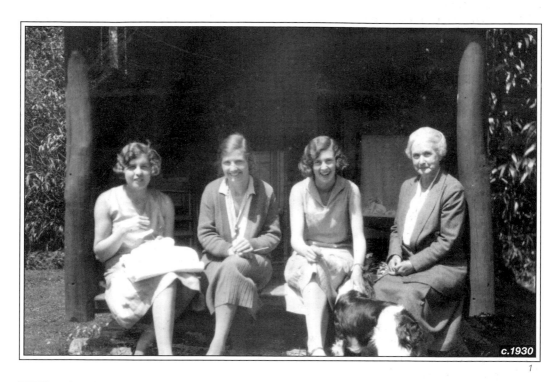

c.1930

1

The sleeveless summer dresses of the two younger women reflect the simple, narrow lines of the later 1920s, but hint at the emergence of a more feminine look as the natural waistline was redefined. Both have the short, waved hairstyles of the later 1920s/early 1930s.

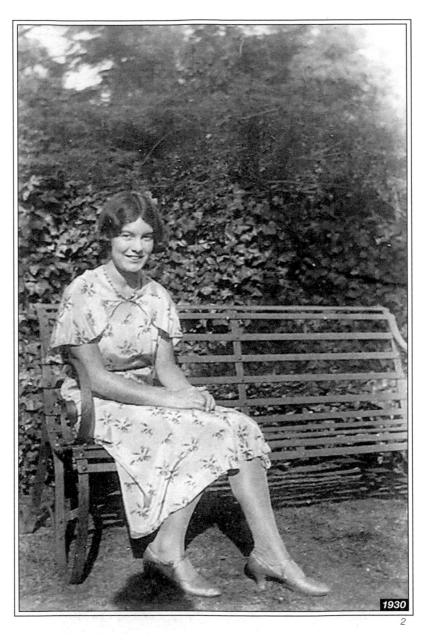

1930

2

A formal afternoon outfit comprising a dress with a matching shoulder cape, a fashionable 1930s combination. Softly draping fabrics enhanced the natural lines of the figure and there was a developing taste for prettier floral fabrics. Stockings in new beige and fawn tones accompanied the shorter skirts of the late 1920s and early 1930s.

Pleats were very fashionable during the later 1920s/early 1930s and hemlines were still fairly short in 1930 and 1931, but were noticeably fuller than those of the previous decade. Plain court shoes (right) were becoming the most fashionable style by now, although various other new designs, such as the low-backed mule-style shoes worn on the left, were also coming into vogue.

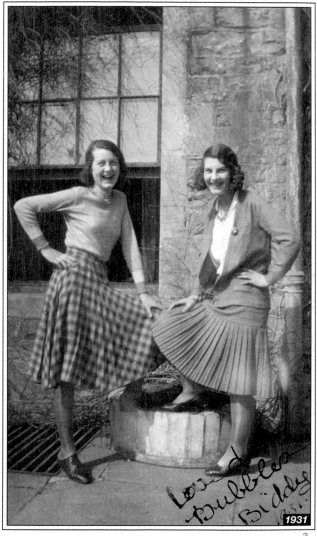

3

June 1932

4

The simple white summer dress represents a general style worn by female toddlers from the 1920s through to the 1960s – short in length, the full skirt being gathered onto a yoke across the chest. This little girl wears a voluminous sunbonnet of printed cotton, tied with strings under the chin. Although it was acceptable – and fashionable – for both adults and children to have a suntan by the 1930s, floral bonnets continued to protect infants' heads for years to come.

A London high school class in 1932 or 1933, the pupils aged around 14 or 15 and approaching the end of their schooling. The girls wear regulation gymslips, white shirts or short-sleeved sports shirts with long, pointed collars, and ties. This style is helpful with dating for it differs significantly from the smaller collars and tucked-in ties which were fashionable for schoolgirls just a few years earlier (see The 1920s, photograph 20) Another dating clue is the girls' and female teachers' hair, which is still bobbed but is smoothly-waved close to the head. The boys' rather diverse appearance reflects the growing tendency towards informality in dress.

1932/33

5

Smart tailored styles of outdoor garment were fashionable, this young woman's calf-length hemline suggesting a date of at least 1931. Small, neat hats were in vogue early in the decade, her beret being a popular style of these years. Her husband is also fairly fashionably-dressed, with wide trousers and a V-necked pullover beneath his lounge jacket.

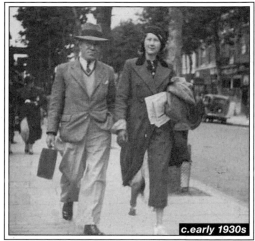

c.early 1930s

6

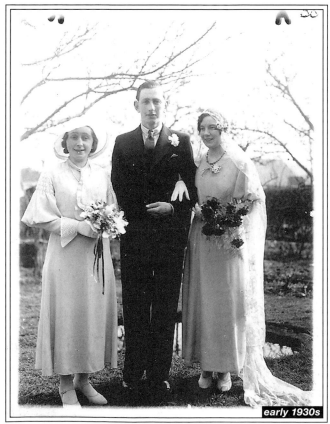

early 1930s

7

The slender, fluid silhouette of 1930s dress was achieved by the bias cut of the fabric, which clung to the hips and fell in soft folds to the hem. Sleeves puffed above the elbow were one of several fashionable early-1930s styles. The bride's close-fitting headdress and long, trailing veil are typical of the early-1930s and she wears high-heeled court shoes. The older lady's gauntlet gloves and wide-brimmed hat are up to date accessories.

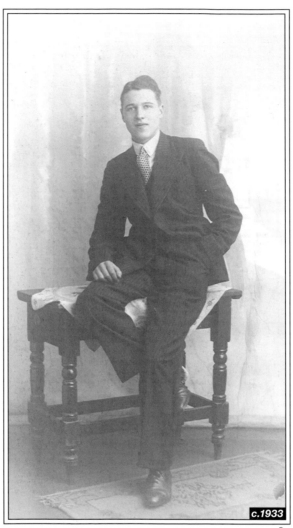

c.1933

8

This young man, aged 20, is smartly dressed in a three-piece suit which was still correct for professional and business wear during the 1930s. His shirt collar looks to be lightly starched (the use of starch only finally dying out with the outbreak of the Second World War) and his silk tie is patterned with small motifs. Black, laced Oxford shoes were the style most commonly worn during the 1930s, and feature the characteristic, pointed toes of the period.

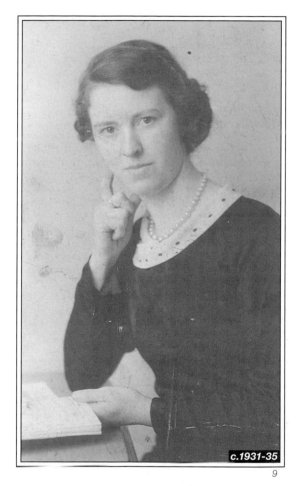

c.1931-35

9

S tudio portraits of the 1920s and 1930s typically paid close attention to the face of the subject. A date of early-mid decade seems likely, for the subject's smart day dress shows no sign of the accentuated shoulders which were beginning to become fashionable from around 1934 onwards.

These women are well-dressed for a shopping trip in town. The older woman (left) wears a dress and matching long jacket, or 'coatee', a fashionable 1930s combination, while her companion wears a dress and short, neat cardigan. Her close-fitting, rounded hat with an angled brim reflects the neat styles of headwear favoured during the first half of the decade.

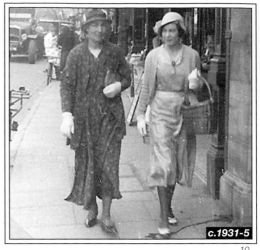

c.1931-5

10

This bride wears a narrow, floor-length gown made from satin fabric woven with a damask-like pattern. White, as opposed to ivory, was becoming usual for bridal wear. Her neat, rounded bridal cap, worn towards the back of her fashionably-waved hair, is attached to a veil which merges with the long, lace-edged tulle train. The bouquet of white arum (or calla) lilies is typical of the decade, their simple, graceful form complementing the elegance of the bride's outfit. The bridesmaids' elaborate bodices feature silver or gold lamé shoulder panels and lower sleeves, the puffed upper sleeves a popular 1930s style.

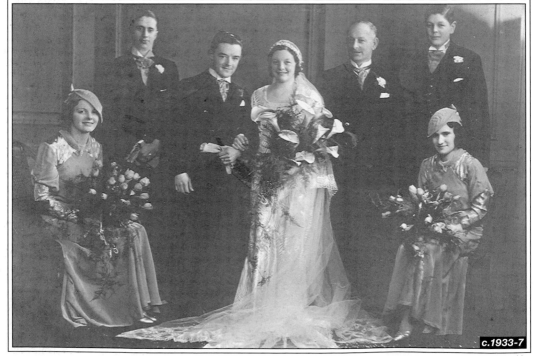

c.1933-7

11

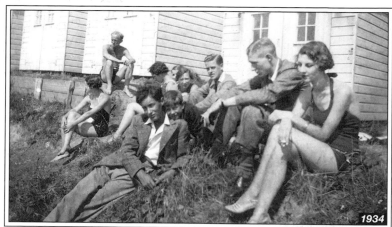

This snapshot taken at Barton-on-Sea shows a group of young people dressed for the beach, their relaxed, languid pose very evocative of the decade. The earlier concealing one-piece women's bathing suits of clinging jersey had radically altered in design by the beginning of the 1930s to more glamorous low-backed costumes with thin shoulder straps or halter necks.

1934

12

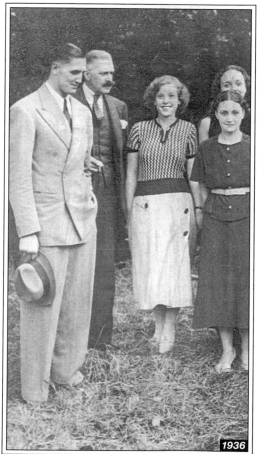

At the judging of a beauty competition at a country fete in 1936, one young woman wears a knitted short-sleeved jersey top whose square shoulders demonstrate the fashionable broadening and accentuation of the shoulder line seen from around 1934/5 onwards. Her companion wears a belted, matching two-piece ensemble, another popular daytime combination. The young man is very fashionably dressed. The broad, well-padded shoulders of his jacket give the desired width to the upper body, emphasising the slimness of the hips. His trousers are cut very wide and long with fashionable turn-ups.

1936

13

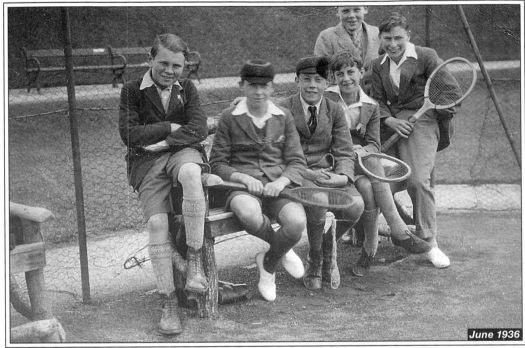

June 1936

14

Sometimes photographs of schoolchildren in uniform can appear daunting, especially where they represent the 'timeless' schoolboy image seen here, which prevailed from the 1920s until at least the 1950s. The principal dating clue here is the lack of ties and the spreading of their open shirt collars over their jackets, a style characteristic of the 1930s.

August 1937

15

Short, bobbed hair was the most usual style for girls throughout the later 1920s and 1930s. The simple summer shift dress, worn above the knees and made with short sleeves and a loose neckline, also accords with this date.

This photograph was taken at Maddieson's holiday camp in Hemsby, Norfolk. Suntanned and revealing their limbs in a manner which only really gained respectability during this decade, a group of friends wear either open-necked, short-sleeved sports shirts or V-necked sweaters, with sleeves rolled up. One wears shorts, newly-fashionable at this time.

c.1937-38

16

1938

17

The clothing of these cycling club members may not appear very 'sporty' to us but nevertheless demonstrates some of the casual styles favoured for outdoor activities by the 1930s. At least two men are wearing shorts, made either knee-length (right) or shorter (towards the centre). Most of them wear white or light-coloured linen jackets, with the sleeves rolled up.

A young cyclist, aged 20, dressed for an outing. His leather jacket, made with a newly-fashionable zip fastening and fitted waist and cuffs, is an early version of what we would now call a 'bomber jacket'. His hairstyle is typical of the 1930s, being cut very short at the sides, the top hair longer, casually waved and combed back over the head.

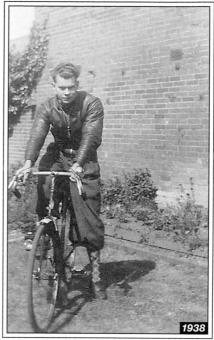

1938

18

A group of walkers or ramblers, predominantly men, the majority of them sporting wide plus fours and thick socks. Some wear lounge jackets with rather formal-looking shirts and ties, but others the more comfortable alternative of sports jackets, similar in appearance to lounge jackets but easier in cut and usually made of tweed fabric

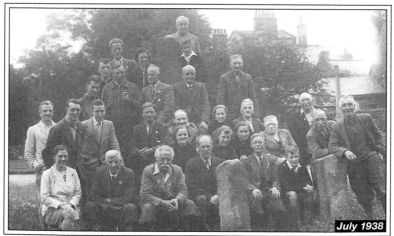

July 1938

19

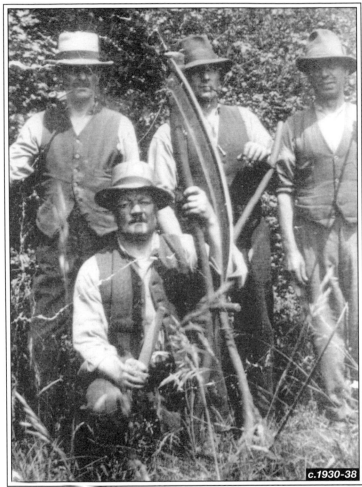

c.1930-38

20

These railway lengthsmen are dressed, like most early 20th century manual workers, in a modified form of everyday clothing based on the lounge suit. This photograph could be broadly dateable to the late 1920s or 1930s, but the man kneeling in front was born in 1890 and died in 1938, so a date range of 1930-38 seems likely. Collarless shirts are a traditional feature of outdoor labouring dress (see The 1900s, photograph 24). Their trousers are cut in the wide style fashionable from the late 1920s until the 1940s. As protection from the sun they wear felt trilby hats or straw panama hats, both popular styles during the 1930s.

This man worked for the postal service between 1937 and 1939 and is wearing a standard issue dark blue jacket and trousers. The jacket, based on the civilian lounge jacket and worn with a regular shirt and tie, replaced the earlier military-style high-buttoning tunic in 1910, and by 1922 featured black, rather than the old-style brass buttons. He still wears the cylindrical *shako* helmet which was introduced for postmen in 1862; in 1932 this began to be slowly phased out in favour of a more modern, flatter style of military peaked cap. Until 1937 a prominent brass badge was worn on the jacket.

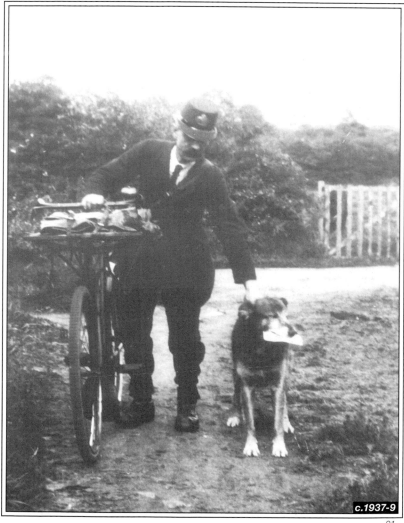

c.1937-9

21

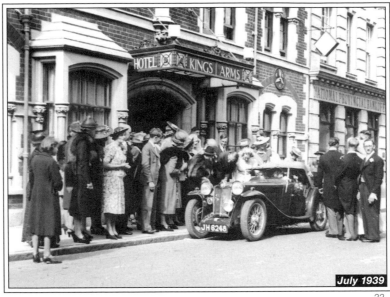

July 1939

22

Little can be seen of the bride but this wedding is interesting for its depiction of late-1930s fashions. Several women wear fox furs over their shoulders, a favourite 1930s accessory – whatever the season. The only male guest visible in full wears a lounge suit with fashionable wide, sharply-creased trousers. The ushers, right, wear black morning coats, the 'correct' wear for a formal wedding at this date.

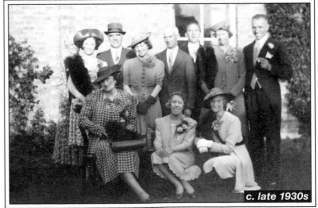

c. late 1930s

23

A group of wedding guests, the women's styles demonstrate the trimmer, more tailored silhouette of the late-1930s, characterised by square, padded shoulders and significantly shorter hemlines. Gloves and hats completed an outfit, most hats here in the low-crowned, broad-brimmed style which was most popular late in the decade.

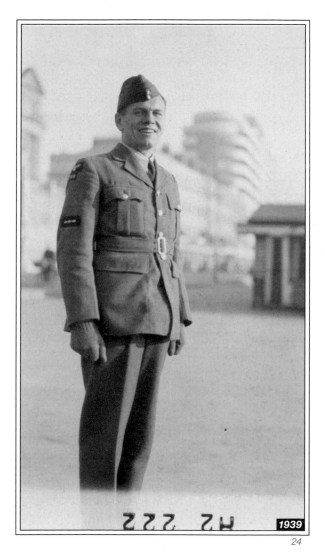

24

The uniform worn by this young man is the standard RAF issue of the wartime period, including the field service cap introduced in 1939. At the top of his jacket sleeves appears the RAF eagle badge worn by all RAF other ranks. Below are the letters VR which demonstrate his membership of the RAF Volunteer Reserve, created in 1936, and indicate that he joined before the outbreak of war. The badge above his elbow bears a twin-bladed propeller, confirming his rank as Leading Aircraftman.

The 1940s

Photographs

The 1940s were dominated by the Second World War (September 1939–May 1945) and luxury items such as cameras for personal photography were, naturally, not a priority during the war itself or the period of austerity that followed. Developments such as the introduction of the first 35mm SLR camera in 1937 were scarcely noticed, and amateur photography continued to rely chiefly on the box and folding cameras of the 1930s, which remained popular until the 1950s and account for many of the 1940s 'snapshots' in family collections. There was still a demand for professional portraits during these years, though, when families were often separated for months if not years.

The war, not surprisingly, provided the subject matter for many photographs dating from the first half of the decade. Young men and women posed proudly before the camera in their smart new service uniforms, families gathered in photographs to say goodbye to relatives in the armed forces, or to celebrate their return, while those based in different parts of England or serving overseas captured their wartime experiences in images which would become enduring mementoes of this extraordinary time. Daily life during the war was also recorded in photographs, and special occasions such as weddings, which were often organised at short notice to fit in with leave arrangements.

Post-war photographs, predictably, are more varied in their subject matter, representing the usual variety of everyday scenes and formal occasions. However, there are noticeably more men present, and everyone is back in civilian dress again, although this was a period of general hardship and life for many did not return to 'normal' for some years.

Dress

Thousands of women spent much of the period wearing a uniform of one description or another, perhaps having voluntarily joined an organisation such as the British Red Cross Society, the Women's Land Army or the Women's Voluntary Service – to name but a few. Others volunteered or were conscripted for the services, the ATS (Auxiliary Territorial Service), the WRNS (Women's Royal Naval Service) or the WAAF (Women's Auxiliary Air Force). Photographs of women wearing wartime service uniforms are usually identifiable and closely dateable from their general styling and distinguishing badges (1, 16).

As in the First World War, many able-bodied women who had not joined the services were employed in work previously carried out by men, and often adopted practical, more masculine styles of dress suited to their new roles, including trousers (6). Up until this time trousers or 'slacks' for women had been reserved mainly for leisure pursuits such as golf, sailing or gardening and as beach wear. However, some young women, becoming used to wearing dungarees, trousers or jodhpurs at work, took this further by donning practical trousers when off duty (9), beginning a trend which was to continue after the war.

In general, though, fashion effectively stood still during the war years, there being little opportunity for 'dressing up' and little to dress up in, as shortages of everything became increasingly acute. Clothes rationing was introduced by the government in June 1941, as part of a comprehensive programme aimed at a fair distribution of scarce but essential goods, and from 1942 the Utility clothing scheme strictly governed the design and production of cloth and garments. Under the scheme, trimmings were banned and the number of buttons, the use of pleats and the widths of sleeves, skirts and hems were restricted, so that the existing trim, tailored styles which had evolved during the late 1930s were reduced to a smart yet austere, almost military look which echoed the uniforms of the period.

This economical wartime image was characterised by dresses and suits made with broad, padded shoulders and narrow sleeves, fitting closely in the body, sometimes belted at the waist, and having narrow A-line or modestly-pleated skirts which ended around knee level (2, 10, 13, 15). A degree of sophistication was sometimes introduced by the ruching or shirring of fabric, which produced a gathered effect, material being too scarce for more elaborate arrangements (2, 10, 12, 15, 20).

Since clothing essentially lacked variety, accessories, hairstyles and cosmetics assumed an increasingly important role during the 1940s. Footwear generally had to be hardwearing and practical, and during the war and its aftermath the predominant everyday civilian style was a substantial laced shoe with a small or medium heel (2, 8, 10, 21, 22), although more attractive, high-heeled shoes were worn for leisure wear or special occasions (10, 15). After the war more varied styles became fashionable (18, 19).

The main focus of attention, however, was on the head. Hats were not subject to rationing and neat, stylish hats perched forward on the head at a jaunty angle did wonders for a woman's appearance (10, 15). Hairdressing was the principal means by which women contrived to maintain and exude a sense of glamour, and the admired war-time style involved the rolling and pinning of the front hair back off the forehead, while the back was softly waved or curled to around shoulder length (10, 15). Such 'perfect' styling was not always practical, but throughout the decade women in or out of uniform generally wore their hair away from their face and waved or curled to the nape of the neck or longer (1, 2, 6, 8, 9, 16, 20).

The austerity of the war years continued into the post-war period when shortages were, ironically, even more acute: clothing was still rationed until 1949 and the Utility scheme persisted until 1952. However, fashion was revived with the launch of Christian Dior's 'New Look' in 1947, which marked a welcome return to more feminine, glamorous styles based on soft, rounded shoulders, a shapely bust-line, narrow waist and full skirts which extended well below the calf. It required many yards of fabric and was not immediately

widely adopted in its most exaggerated forms, although the new fashionable silhouette is evident in photographs dating from as early as 1947 (18). Its influence on the development of post-war fashion was, however, far-reaching, and towards the end of the 1940s even the skirts worn by middle-aged and elderly women generally have a fuller, more flared appearance (21, 22).

A wide divergence between the dress of older and younger women is evident in post-war photographs, more mature and conservative women generally appearing in practical or 'classic' styles of dress, or blouse and skirt, and pursuing the long-standing tradition of wearing hats when in public (21, 22, 23). Conversely, many young women were veering more and more towards casual, informal styles, reflecting the growing American influence on British fashion at this time. Stylish, comfortable separates became increasingly popular, giving the impression of a more extensive wardrobe at a time when clothing was still in short supply (19).

When war broke out in September 1939, all men aged between 18 and 40 were liable to be called up for National Service, this being extended in December 1941 to include those aged up to 51. Most photographs taken between 1939 and 1945 therefore depict male adults wearing service uniforms of one form or another, and as is usual with uniformed subjects, these are generally closely identifiable and dateable (2, 3, 4, 5, 9, 14, 15).

Sometimes young men were 'snapped' off duty, dressed for leisure activities in casual clothing and sportswear familiar from the previous decade (7, 9). Men who do appear in wartime photographs wearing everyday civilian dress – usually older men or those in reserved occupations which did not require a uniform – are generally dressed in the customary lounge suit, comprising the broad-shouldered jacket and wide trousers carried over from the 1930s (8, 15).

Following the end of the war in Europe in May 1945, men leaving the armed services were issued with a set of civilian clothing popularly known as a 'demob' suit, which comprised a shirt and tie, a square-shouldered, double-breasted jacket and loose fitting trousers. In the following years, there was a renewed interest in dress, especially amongst younger men, who ordered new suits featuring the fashionable details such as turn-ups and pleats on trousers which had been prohibited during the war (17, 18). Suits remained the 'correct' wear for work, although coloured shirts and woollen pullovers and waistcoats were acceptable in many jobs (17, 18). The short back and sides hairstyles and clean shaven faces worn in wartime continued in fashion into the 1950s (17, 18, 24), although sometimes older men favoured a neat moustache (21).

Girls' clothing during the 1940s was influenced partly by a contemporary interest in European folk art, expressed through gathered 'peasant' blouses and embroidered 'Tyrolean' cardigans, and partly by the tailored garments worn by women. Hand-knitted garments and home-made blouses were popular, especially during the war, as were economical, Utility-style dresses, made, like adult clothing, with padded shoulders and narrow, knee-length skirts, which could look rather incongruous with short white socks and 'sensible' laced shoes (10). Many girls' schools continued to insist on school uniform, despite the hardships of war. Some had already switched to a more modern unpleated pinafore, although most retained the traditional pleated gymslip, and schoolgirls after the war looked much as they had done before it (24).

Boys continued to wear shorts until they were old enough to wear long trousers – Utility regulations in force from 1942 actually prohibited manufacturers from making long trousers in small sizes. For formal wear, shorts were teamed with a shirt and tie (8). Jackets, when worn, were a miniature version of men's broad-shouldered styles. For casual and play wear, comfortable knitted jerseys were still fashionable (12) and could be made at home, old jumpers often being unravelled and re-knitted. Boys' shirts were often made from cut-down men's shirts. Small boys wore the popular button and braces 'buster suit' (11), named after an American cartoon character – the button fastening was a practical measure when elastic for waistbands was scarce.

Outer wear was still cumbersome and tailored-looking (22) and in general, boys' clothing seen in 1940s photographs appears rather traditional and formal, compared with the casual and more varied styles, deriving from youthful American fashions, which were to become available during the 1950s.

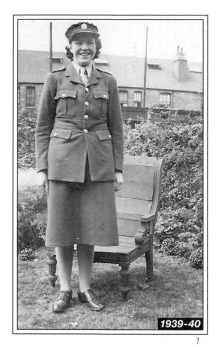

1939-40

1

This young private wears the standard uniform issued to members of the Auxiliary Territorial Service. The jacket is distinguished by its brass buttons and metal shoulder titles bearing the letters ATS. Her cap, with the ATS cap badge, is made in the early style, which featured a cloth cap band, and therefore dates the uniform more closely. In time, the wartime duties of the ATS expanded to include many jobs previously carried out by men and accordingly they were issued with a version of the male battledress jacket and trousers.

Trim, tailored dresses had become fashionable by the end of the 1930s, characterised by broad shoulders – emphasised here by the puffed sleeves - and a short skirt worn around or just below the knee. Already, in 1940, the slender lines demonstrate an economical use of materials, which became essential as the war progressed. The soldier wears the standard khaki battledress of the British Army, which was used throughout the Second World War, with the style of field service cap worn until late 1943.

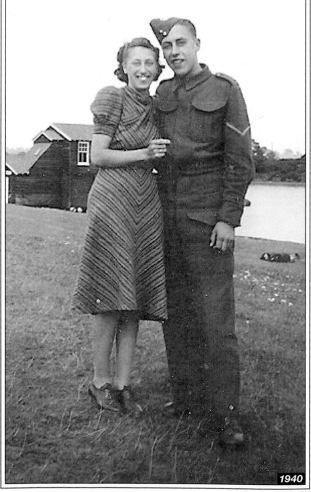

1940

2

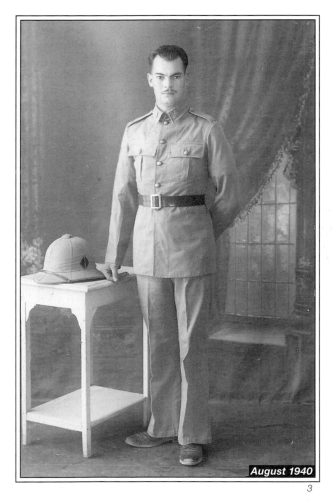

August 1940

3

This private in the Royal Army Ordnance Corps, aged 22, served for the first years of the war in Egypt and he wears the standard khaki drill jacket and trousers issued to the British army in most hot climates. Just visible are his brass shoulder titles which bore the letters RAOC. The Wolseley helmet was a version of the pith-helmet which was introduced in 1902 for army wear overseas. Made of cork and lined with foil, it was bound with a cloth bandage or *pagri* to minimise the effects of the heat. It bore coloured flashes rather than a metal cap badge.

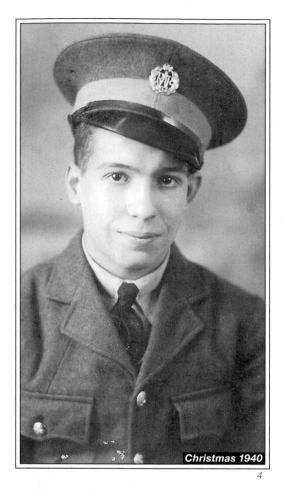

Christmas 1940

4

The most significant feature of this portrait of an RAF apprentice is his cap band, which is clearly pale-coloured, whereas the band normally worn by airmen was black. Coloured cap bands were worn by RAF apprentices and this is probably light blue, as worn at the RAF Technical Training School at Halton, in Buckinghamshire.

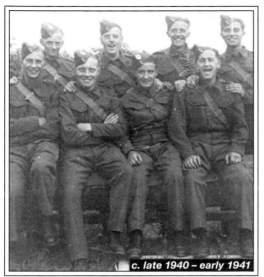

c. late 1940 – early 1941

5

This section (team) of Royal Engineers (RE) all wear regulation khaki battledress, a new style of uniform without brass buttons which was first introduced in March 1939. Later, in 1942, due to the need for economy of materials, pleats and flaps disappeared from pockets. Two of the men wear RE cap badges, one of which is placed well to the front of the cap, a fashion particularly associated with the early war years. Another dating clue is that early on in the war soldiers in uniform always wore the straps of their gas mask cases slung diagonally across their bodies in the manner seen here.

A woman carrying out the daily milk round in 1941, a job performed by men before the war. She exudes a cheerful efficiency, which is matched by her practical, workmanlike appearance in a masculine-style outfit that has no pretensions to femininity. She wears a tailored tweed jacket over a woollen waistcoat or jersey, with a man's style of shirt and tie. Like many women who found it convenient to wear trousers during the war, she wears a pair of hard-wearing riding breeches or jodhpurs.

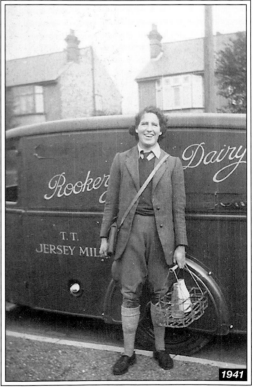

1941

6

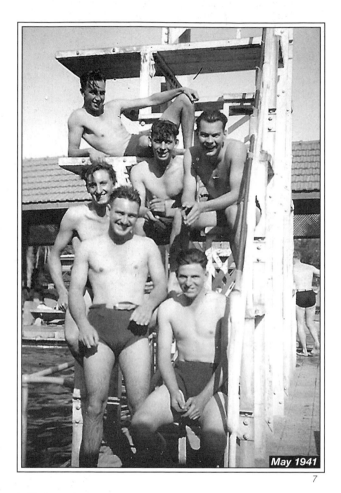

May 1941

7

These young, off duty soldiers are dressed in a relatively early form of men's swimming trunks or shorts. Typically, during the 1940s, they have rather a tailored shape, cut high to cover the navel and incorporate webbing belts which impart a consciously 'dressed' look.

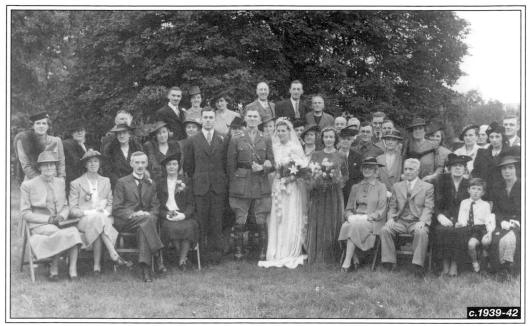

c.1939-42

8

Early on in the war white bridal gowns followed the styles of the mid-late 1930s, based on elegant evening wear. The silhouette was long and narrow, the bodice of the dress made with fashionable padded shoulders and the skirt trailing on the ground. The bride's long veil is also typical of this period, while her bouquet continues the 1930s wedding fashion for white lilies.

The soldier's uniform confirms a date between 1939 and 1943, offering a closer date-range than the civilian dress worn by the other subjects – in late 1943 his field service cap would be superseded by a new style of army headwear. Their female companion wears a pair of trousers made in the wide, tailored style which was fashionable during these years.

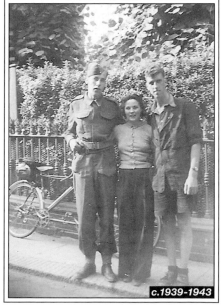

c.1939-1943

9

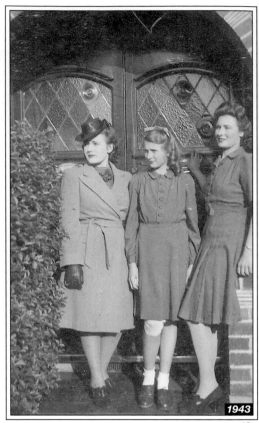

1943

10

Three sisters outside their London home, all wearing Utility-style outfits characterised by a rather austere tailored look, short hemlines and few trimmings. The dress to the right is typical of these years, with its padded shoulders and short sleeves, fitting closely in the body and over the hips, before flaring out gently into a pleated skirt. The sister on the left wears a fashionable coat with padded shoulders and broad revere collar, the cloth tie-belt characteristic of the war years when coats were made without buttons.

1940s

11

The older of the brothers, aged around 3, wears a 'buster suit', the popular blouse and shorts suit which buttoned at the waist with braces. The younger boy, aged perhaps 18 months, wears a white, shortened baby gown with short sleeves and a gathered or smocked yoke. Dresses like this were worn by toddlers of both sexes, although little girls' garments might be more decorative.

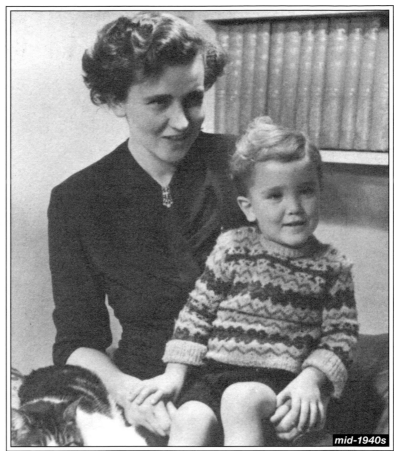

The simplicity of the mother's plain dress, with its square shoulders and narrow lines, is alleviated by the decorative dress clip worn at her neck and by the ruched bodice. Her little boy wears shorts with a knitted Fair Isle jersey.

mid-1940s

12

Short socks, initially worn by young children, had become popular for older girls during the 1930s and by the time of this photograph were often worn by women, with skirts or shorts, for activities such as cycling and walking.

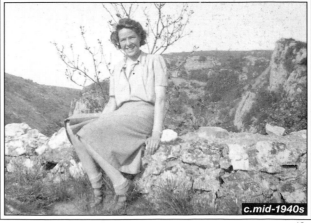

c.mid-1940s

13

FAMILY PHOTOGRAPHS AND HOW TO DATE THEM

This rather glamorous, professional photograph depicts a serving member of the Entertainments National Service Association (ENSA), the organization that 'mobilised' the entertainment industry. In Britain ENSA artistes could wear civilian clothes, but for service abroad they had to have a form of uniform similar to that of the armed forces, in order to benefit from the protection of the Geneva Convention. His cap is a standard khaki officer's service dress cap with brown leather strap. He is wearing an officer pattern light khaki collar and tie, and the open collar of his battle dress uniform jacket is visible under the light-coloured waterproof coat.

c.1943-4

14

By the later years of the war it was generally considered inappropriate to have a white wedding. The bride here, aged 18, is fashionably-dressed in a slim-fitting, fake fur coat with a jaunty pillbox hat. As was usual by this date, the groom, a member of the Royal Canadian Air Force, was married in his uniform, identifiable by the medal ribbon above his left breast pocket, which incorporates a silver maple leaf in the centre in recognition of his service overseas.

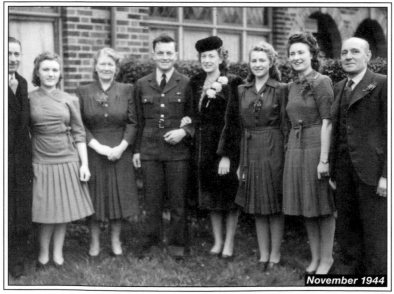

November 1944

15

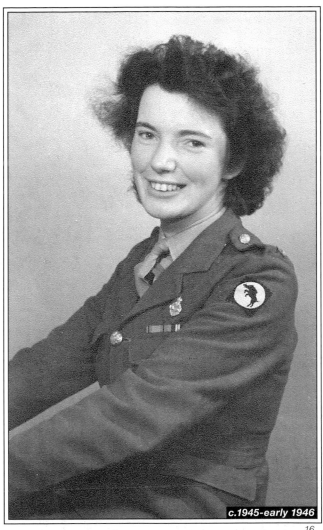

c.1945-early 1946

16

From 1940 the ATS generally wore the collar badge of the men's unit with which they were serving above the left breast pocket of the jacket. This private's badge represents the Royal Electrical and Mechanical Engineers (REME). Her medal ribbons, seen below the badge, include the Defence Medal, awarded to those who had served in Britain for at least three years. The cloth formation sign on her arm represents the black boar of 30 Corps, a large formation which was heavily involved in the liberation of Europe after D-Day. It suggests that the photograph originates from their period as an occupation force in Germany immediately after the war, but must pre-date March 1946, when 30 Corps was disbanded.

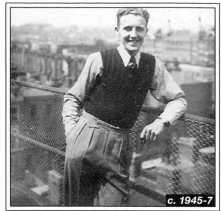

This young man has returned to civilian life in London and wears his everyday office clothes, without his suit jacket. It was quite common for working men to wear a sleeveless pullover in place of a suit waistcoat. The pleated tops of his trousers are a feature not permitted during the war under the Utility scheme.

17

The young man's belted over-coat, tailored in the knee-length, broad-shouldered style, was characteristic of this period. Typically, the lapels are very long, extending to the waist. The lady in the back-ground wears a fash-ionable coat made in the distinctive 'New Look' style which first emerged in 1947, with elegant ankle-strap shoes.

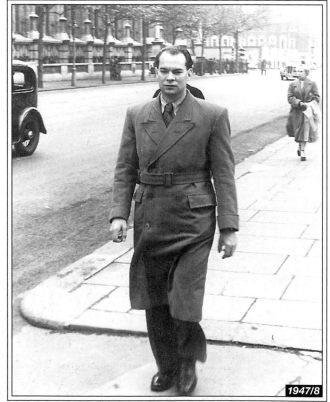

18

This casual but stylish outfit is typical of late-1940s informal youthful fashions. The tailored trousers with knife-edge creases are in the billowing 'harem' style. High-heeled peep-toe shoes were rarely seen during the war years. By 1950 her long, waved hair would be cut short, following the emergence of new fashionable styles. The woman in the background wears a short, floral print sun dress, a style first popularised during the 1930s and often seen in 1940s photographs.

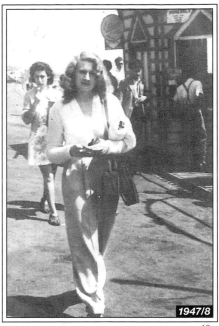

1947/8

19

Fur jackets, capes and stoles, especially in fox fur, had been popular since the 1930s and continued to be worn well into the post-war years. The decorative hats with brims worn by two of the older ladies were generally favoured by more mature women, while the plainer soft hat worn to the back of the head by the baby's mother is more typical of younger women's fashions by the late 1940s.

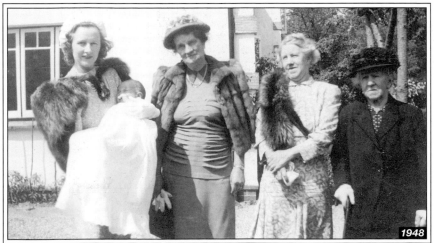

1948

20

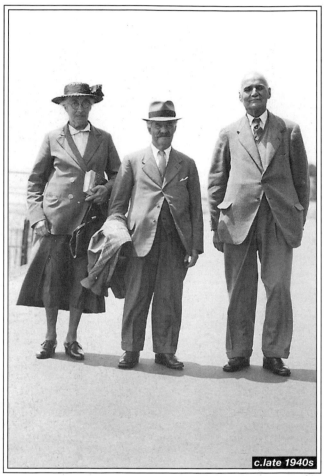

c.late 1940s

21

Being elderly, this group are more formally and conservatively dressed than most younger people by this date, but the lady's flared, pleated skirt shows the gradual return to wider shapes after the introduction of the 'New Look' in 1947. The men's jackets are, typically, single-breasted with only two or three buttons, while the turn-ups on the trousers would have been prohibited during the war.

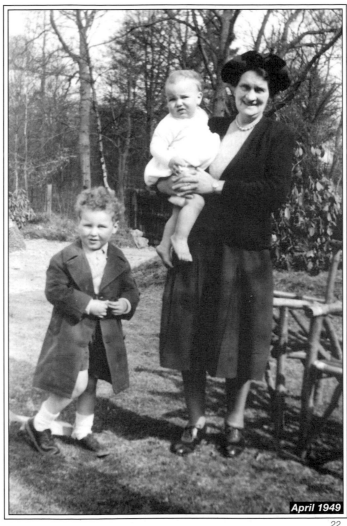

April 1949

22

When clothes rationing ended in Britain, middle-aged women's outfits remained practical and conservative. The substantial, low-heeled shoes are typical of the 1940s. Children often appear rather formal at this time, when dressed for outdoors. The little boy's shoes, with crepe rubber soles, became popular in the post-war period.

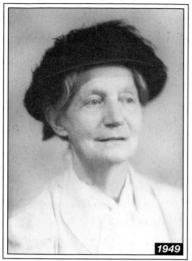

This photograph, which may be a studio portrait, was sent by the subject, aged 80, to members of her family at Christmas in 1949. After the war many older women who had been accustomed to covering their heads in public all their lives continued to wear hats on an everyday basis. This modest, small-brimmed style appears to be trimmed all over with feathers.

1949

23

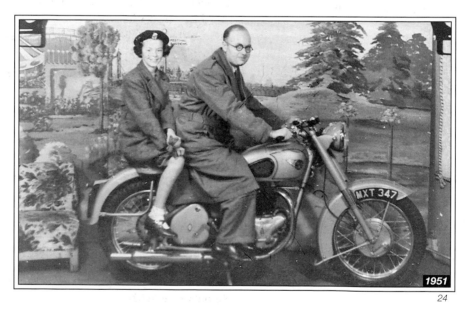

1951

24

Here is a suitable photograph to conclude our book. The man wears a belted mackintosh and wide trousers that were fashionable during the early 1950s. He looks a bit sheepish and his lady passenger somewhat self-conscious. The backdrop appears to be painted and the motorbike is going nowhere. But there are more clues to the date and purpose of the picture.

The motorbike is a BSA A10 Golden Flash, launched in 1950. Behind the girl's head is a sign saying 'Festival Gardens', clearly a reference to the Festival of Britain staged in London during May 1951. So this is likely to be a publicity photograph. I don't know who the man and girl are. Does anyone recognise them?

Further Reading

DRESS
Dress - general
Penelope Byrd, *Nineteenth Century Fashion* (B.T. Batsford, 1992)

Penelope Byrd, *A Visual History of Costume: The Twentieth Century* (B.T. Batsford, 1986)

C. Willett and Phillis Cunnington, *Handbook of English Costume in the Nineteenth Century* (Faber & Faber, 1959)

C. Willett Cunnington, *English Women's Clothing in the Present Century* (Faber & Faber, 1952)

Elizabeth Ewing, *History of 20th Century Fashion* (B.T. Batsford, 3rd ed. 1986)

Vanda Foster, *A Visual History of Costume: The Nineteenth Century* (B.T. Batsford, 1984)

Dress - specialised
Penelope Byrd, *The Male Image: Men's Fashion in England, 1300-1970* (B.T. Batsford, 1979)

Avril Lansdell, *Occupational Costume and Working Clothes, 1776-1976* (Shire Publications, 1977)

Avril Lansdell, *Wedding Fashions, 1860-1940* (Shire Publications, 1983)

Shelley Tobin et al., *Marriage à la Mode: Three Centuries of Wedding Dress* (The National Trust, 2003)

Clare Rose, *Children's Clothes* (B.T. Batsford, 1989)

Elizabeth Ewing, *History of Children's Costume* (B.T. Batsford, 1977)

Lou Taylor, *Mourning Dress* (George Allan & Unwin, 1983)

Army Uniforms
Jon Mills, *From Scarlet to Khaki* (Wardens Publishing, 2005)

For help with uniform identification, Jon can be contacted by telephone: 01689 828619 or email: cdwardens@yahoo.co.uk

Dress in photographs
Miles Lambert, *Fashion in Photographs, 1860-1880* (B.T. Batsford, 1991)

Sarah Levitt, *Fashion in Photographs, 1880-1900* (B.T. Batsford, 1991)

Katrina Rolley, *Fashion in Photographs, 1900-1920* (B.T. Batsford, 1992)

Elizabeth Owen, *Fashion in Photographs, 1920-1940* (B.T. Batsford, 1993)

Alison Gernsheim, *Victorian and Edwardian Fashion: A Photographic Survey* (Dover Publications, 1963)

Avril Lansdell, *Everyday Fashions of the 20th Century* (Shire Publications, 1999)

PHOTOGRAPHS
Audrey Linkman, *The Victorians: Photographic Portraits* (Tauris Parke, 1993)

Robert Pols, *Dating Nineteenth Century Photographs* (The Alden Press, 2005)

Robert Pols, *Dating Twentieth Century Photographs* (The Alden Press, 2005)

Robert Pols, *Looking at Old Photographs* (The Federation of Family History Societies, 1998)

Robert Pols, *Family Photographs 1860-1945* (Public Record Office, 2002)

Index